100 Mandala Coloring Book for Adults
Focus On Living in the Present Moment

Andrea T. Cross

Copyright © 2019 Andrea T. Cross

All rights reserved.

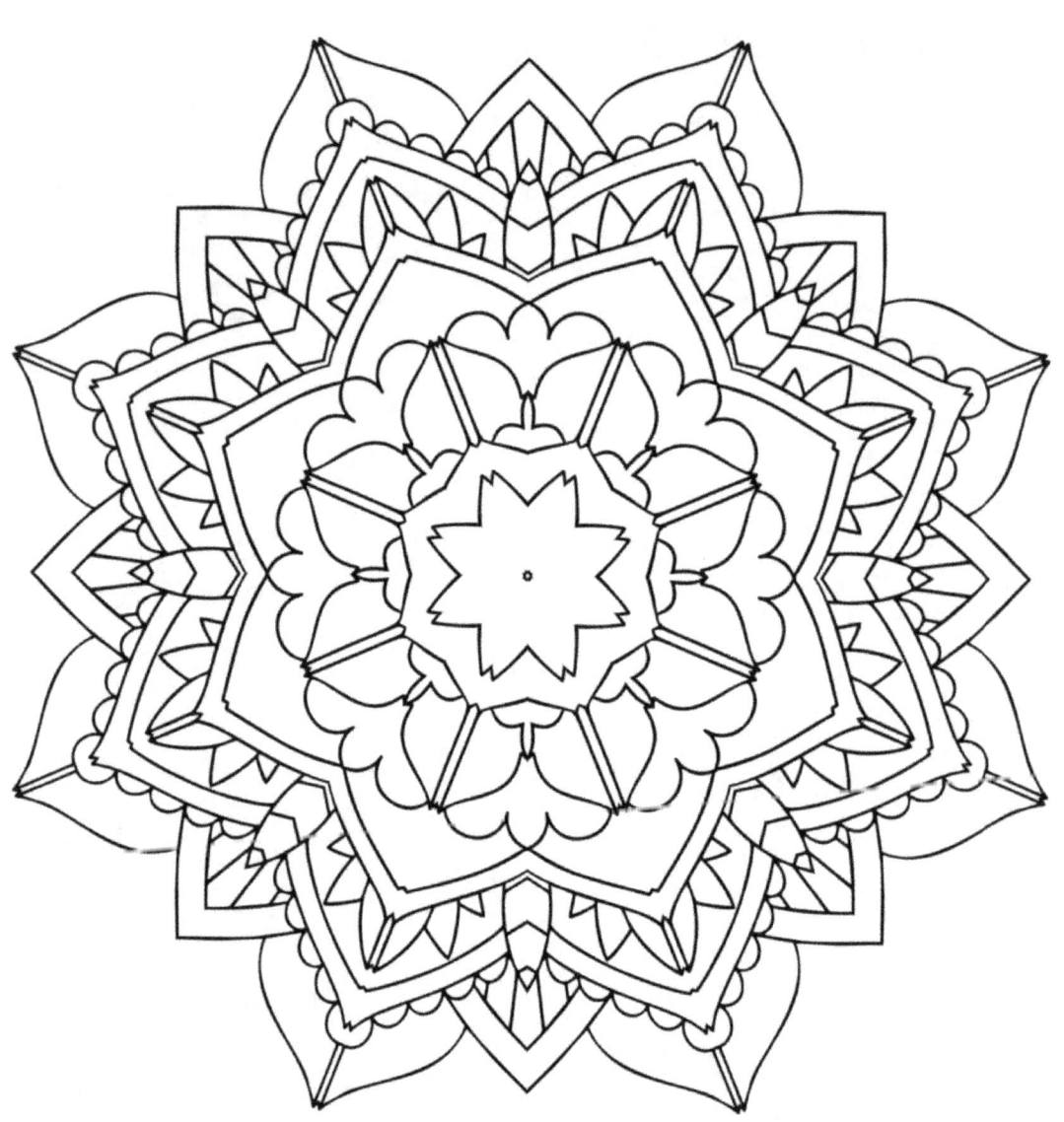

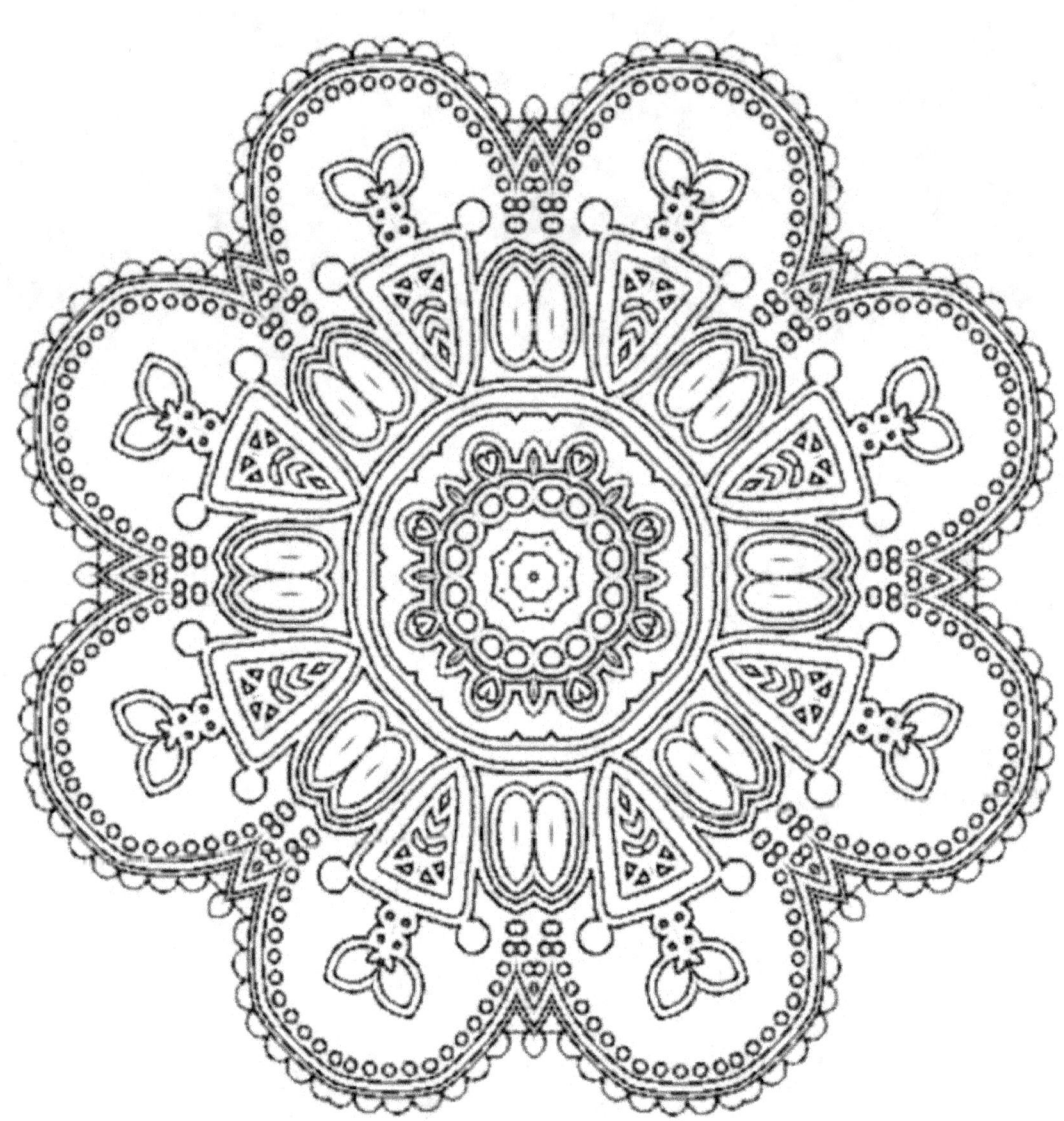

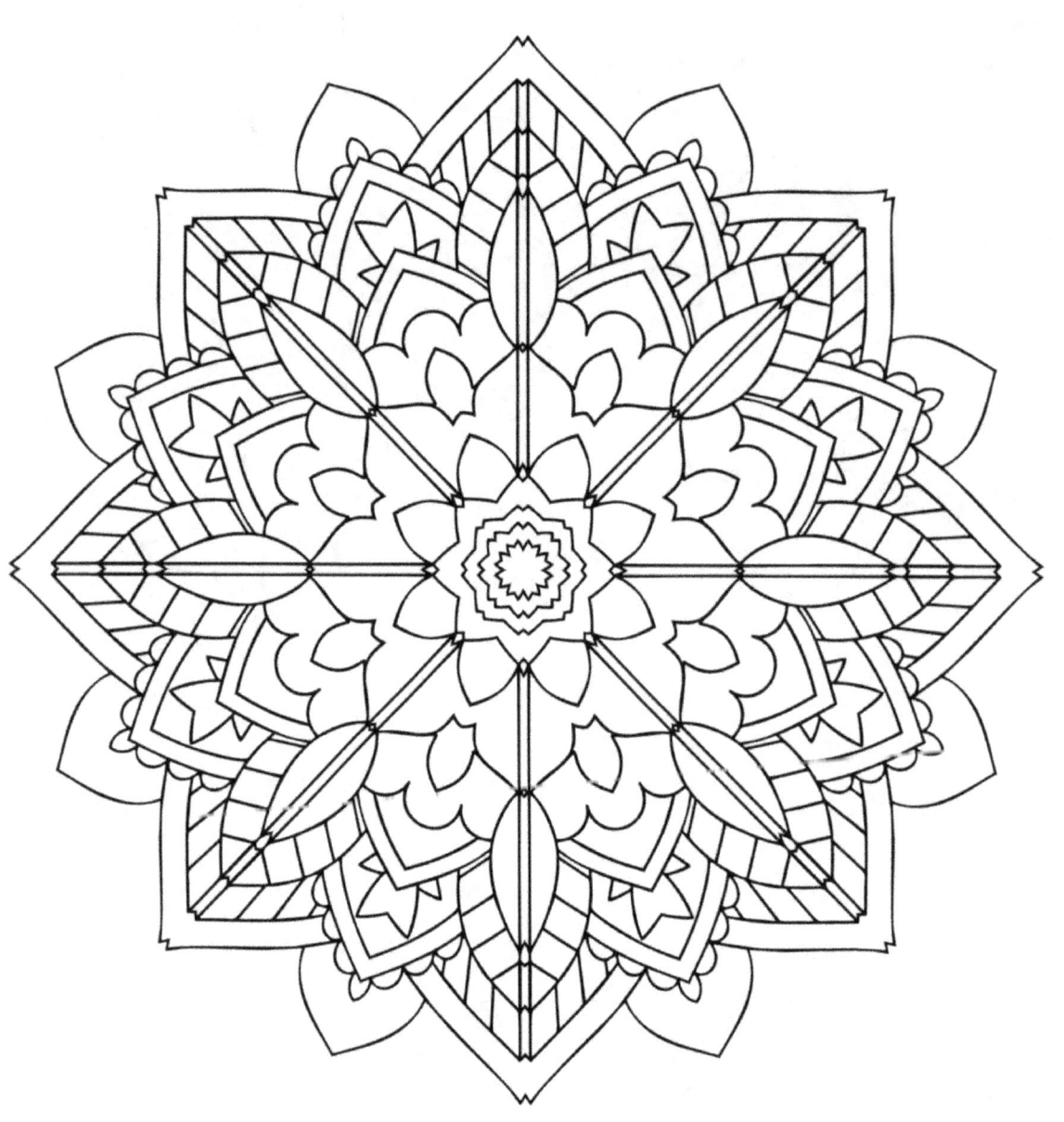

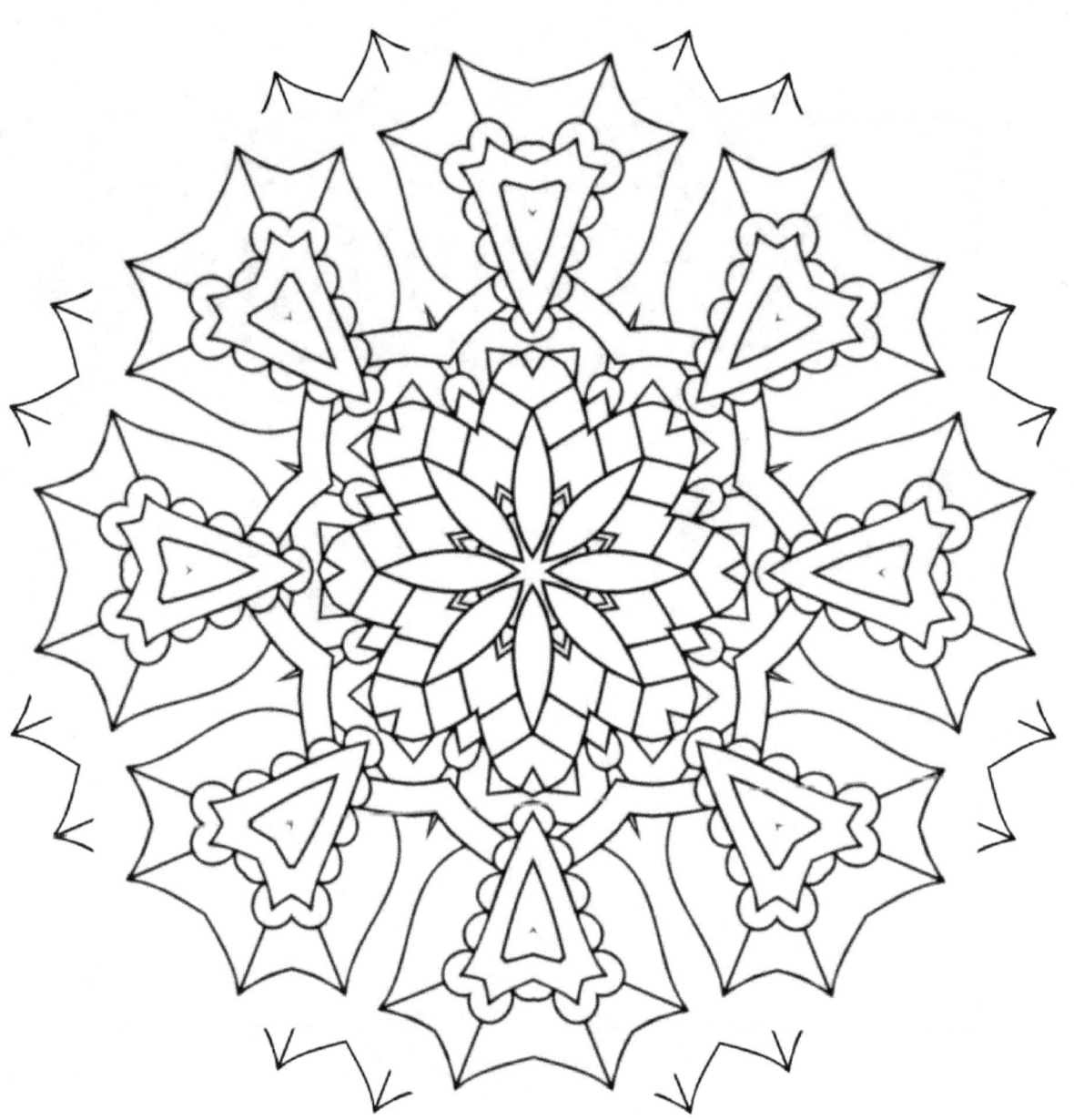

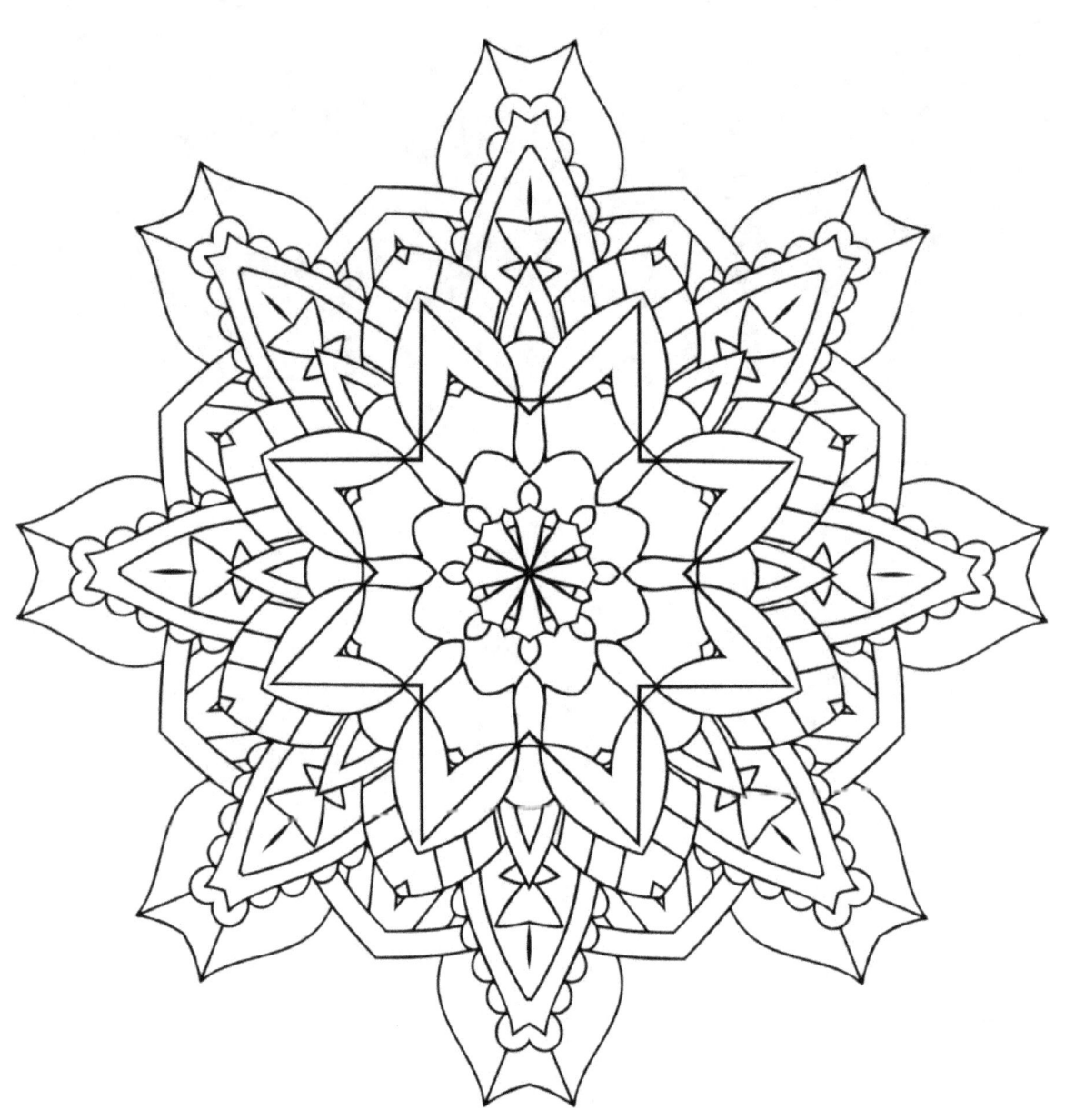

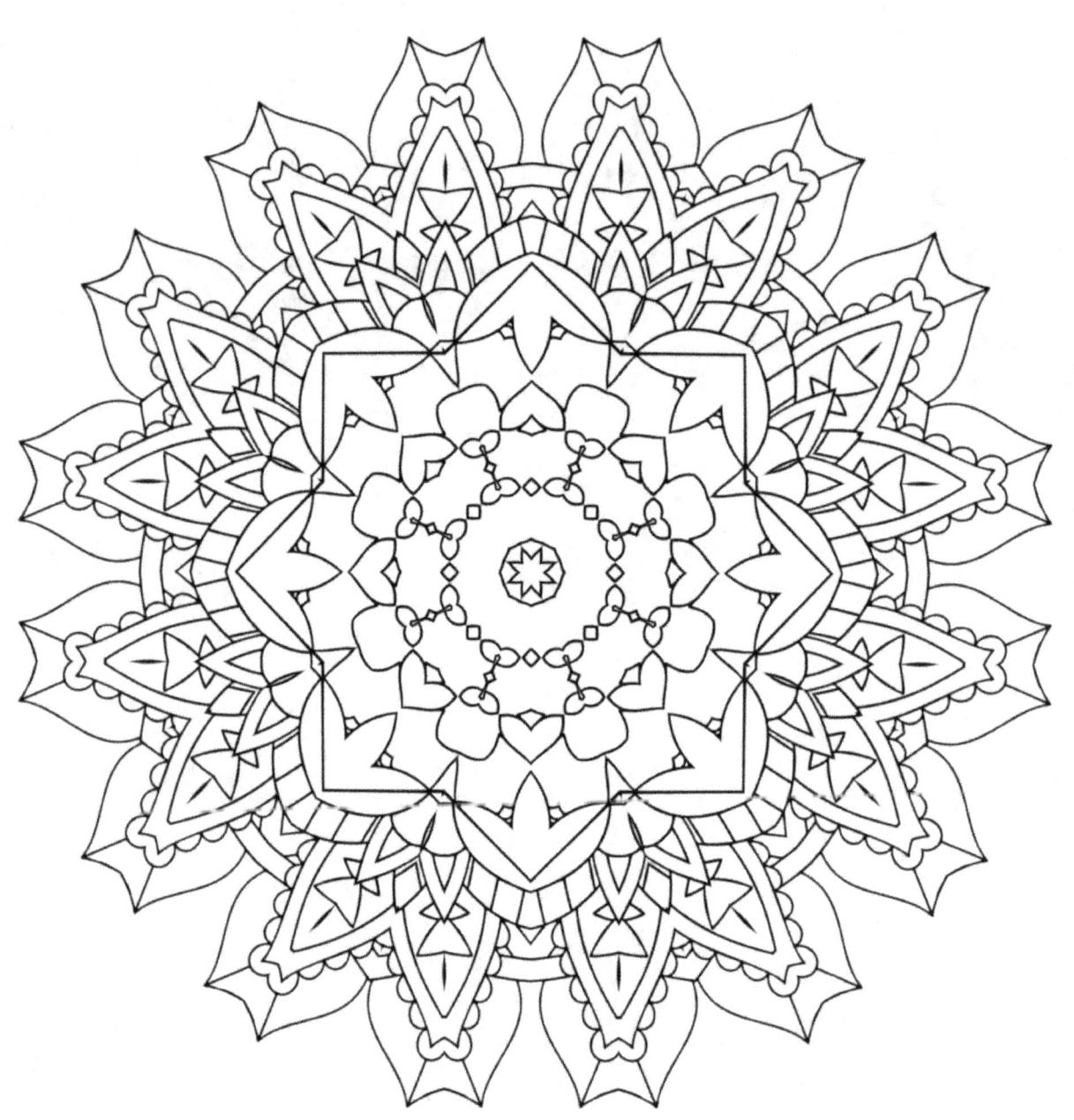

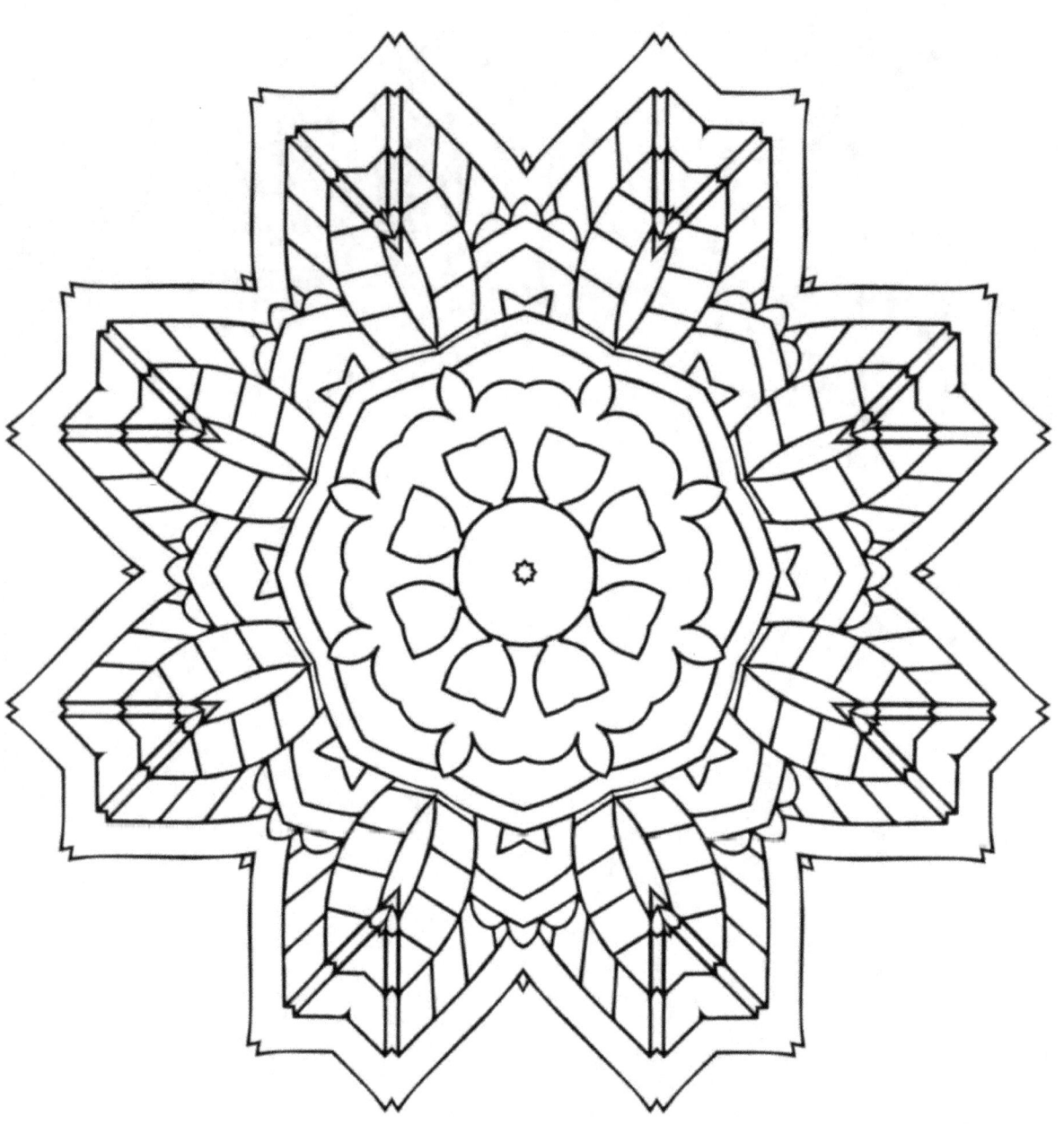

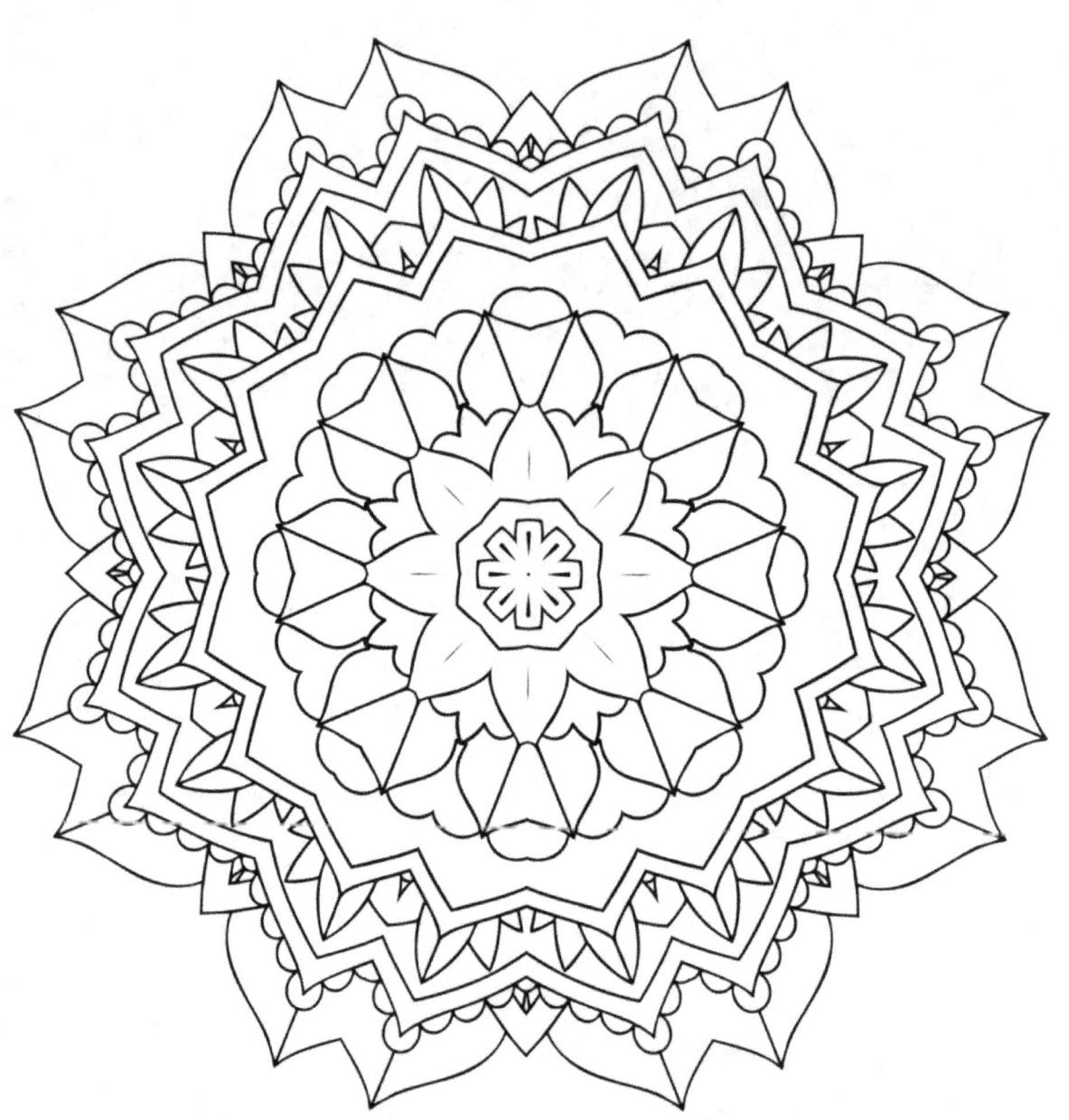

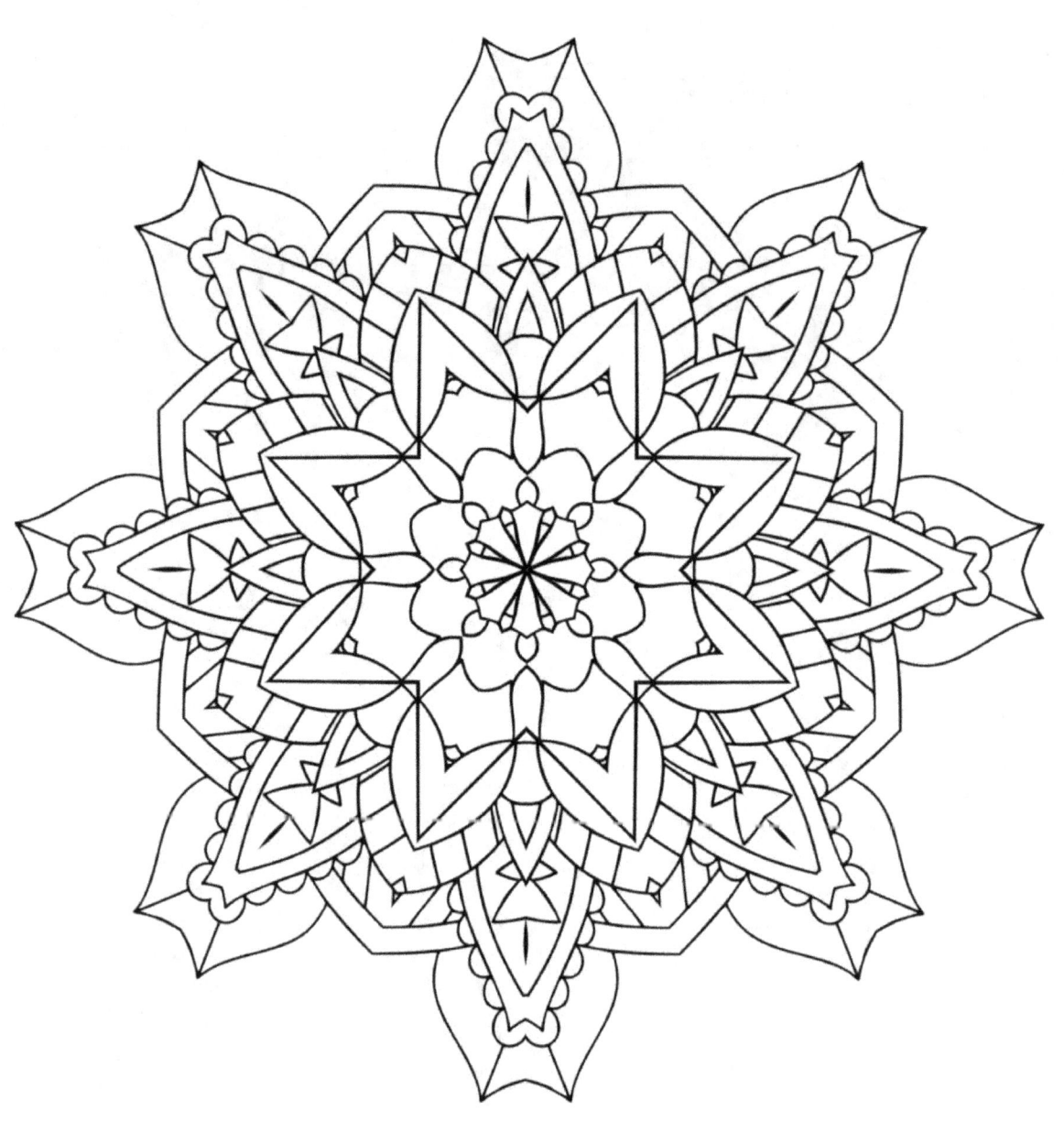

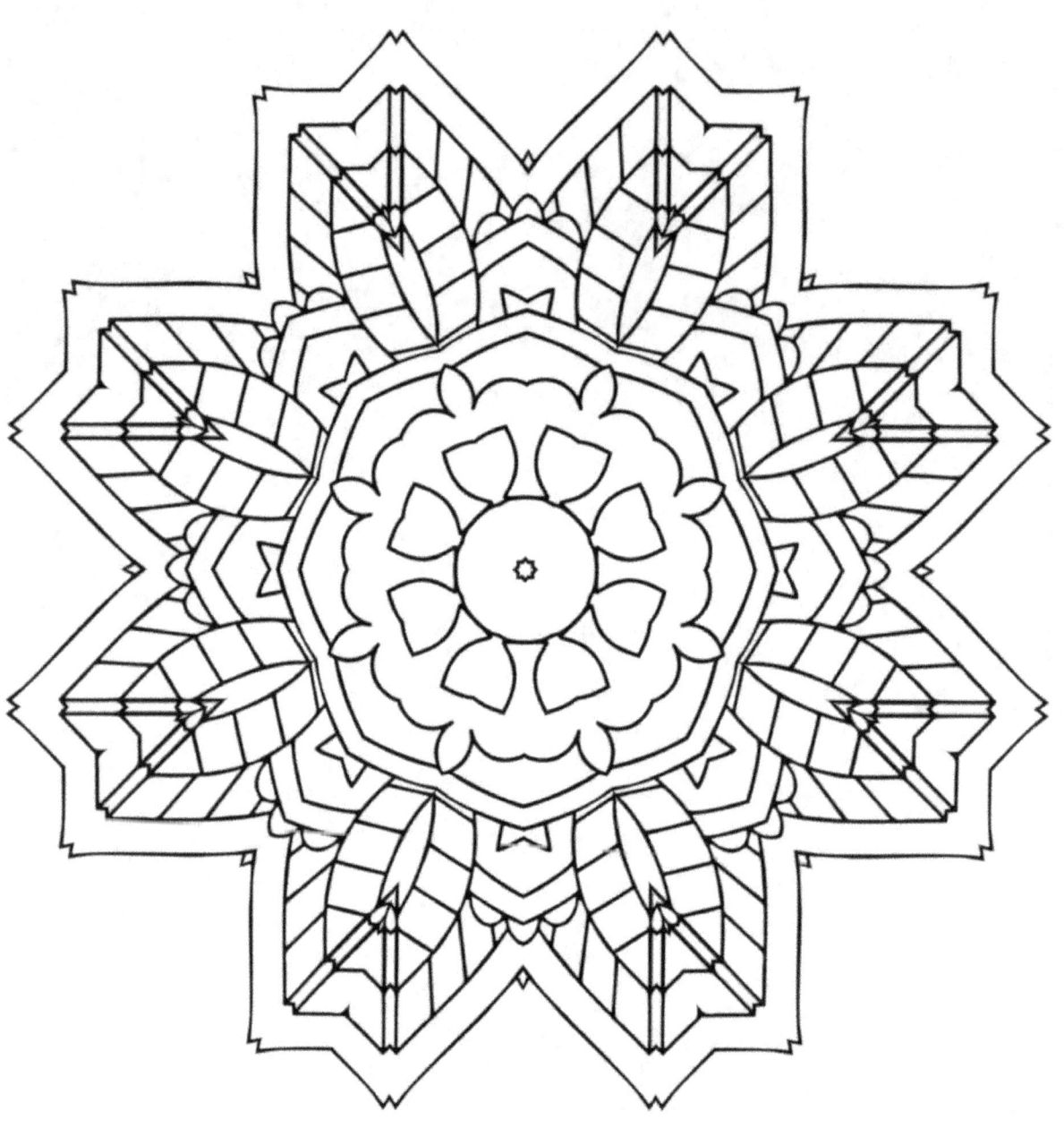

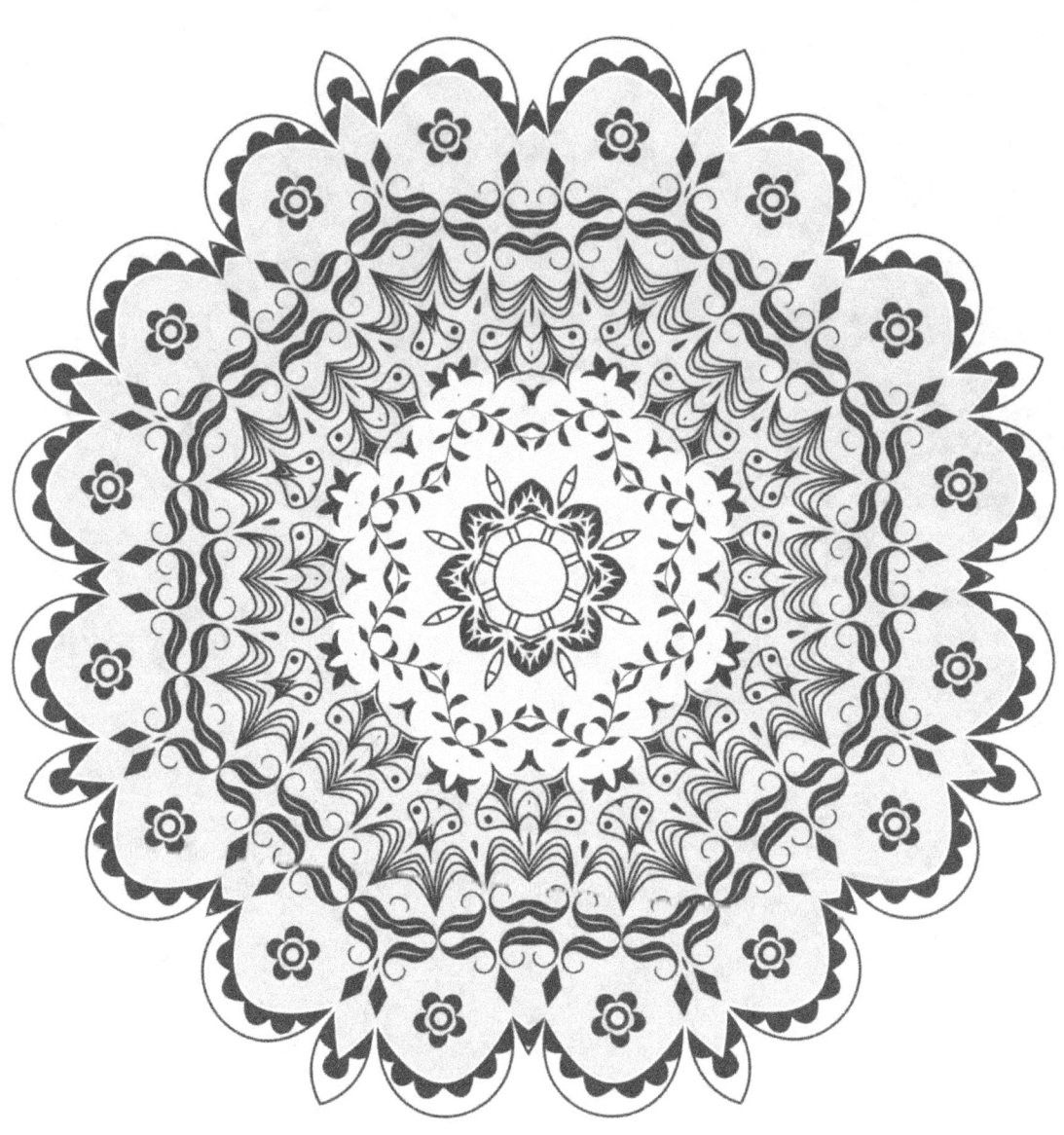

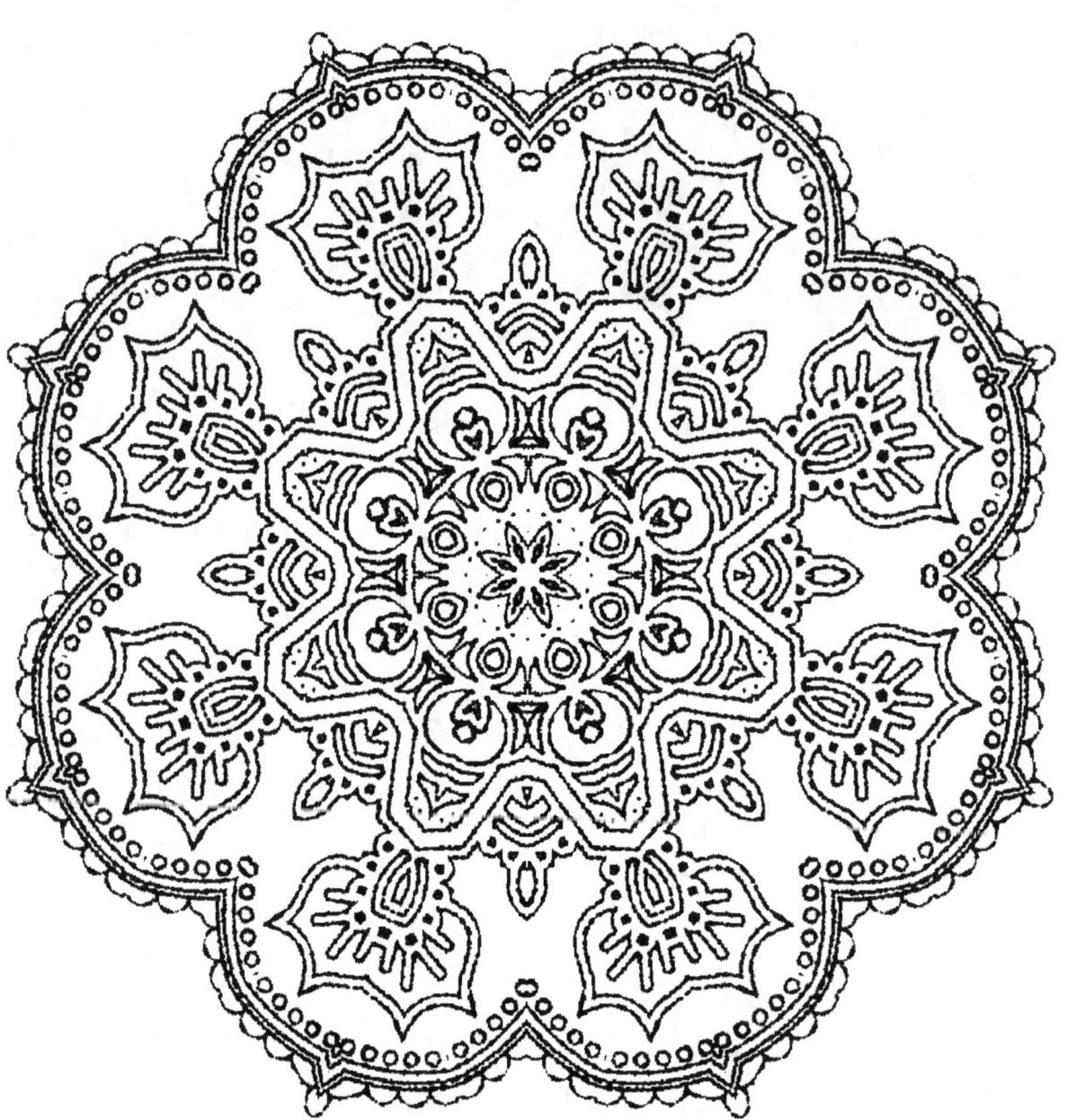

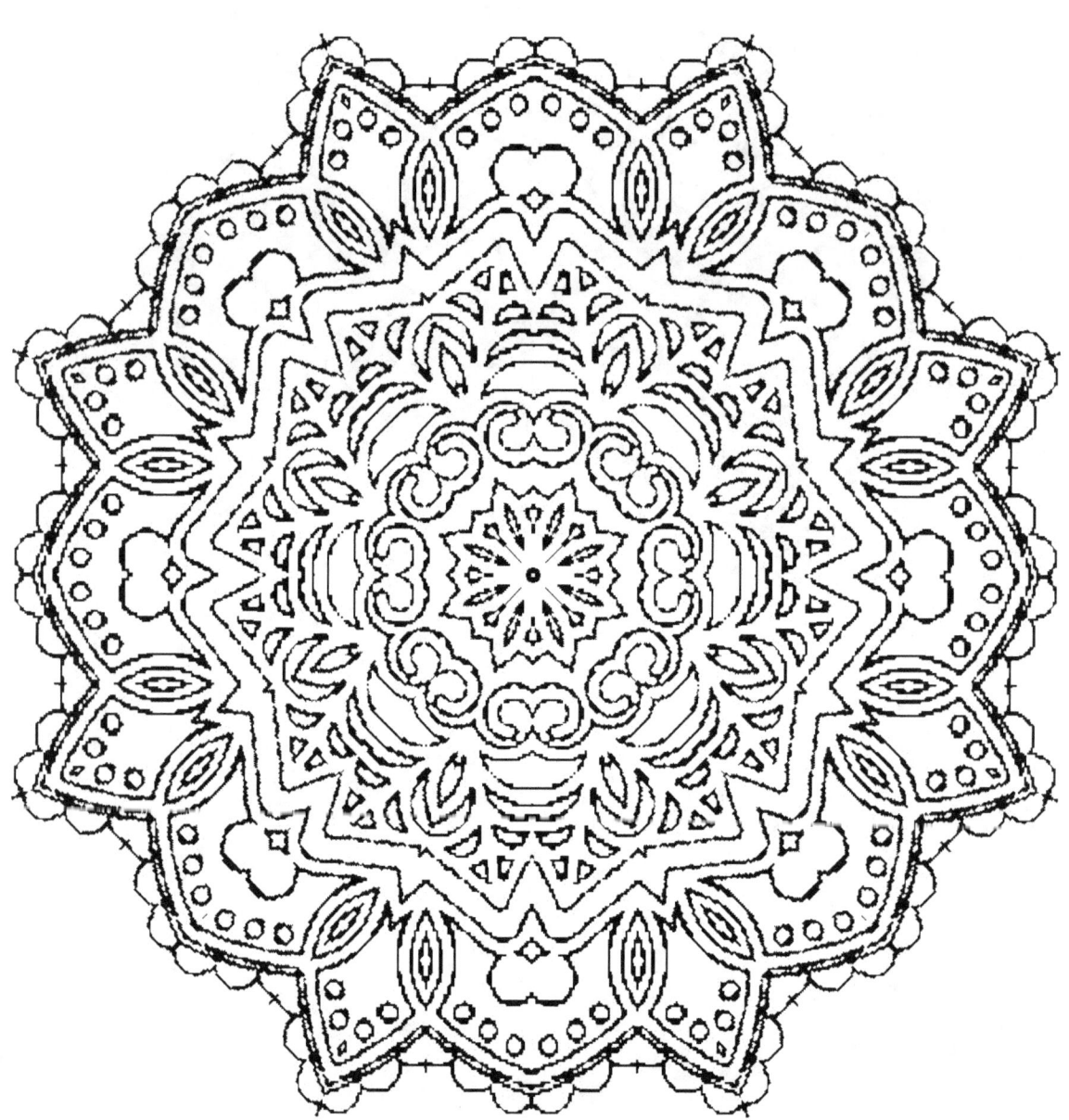

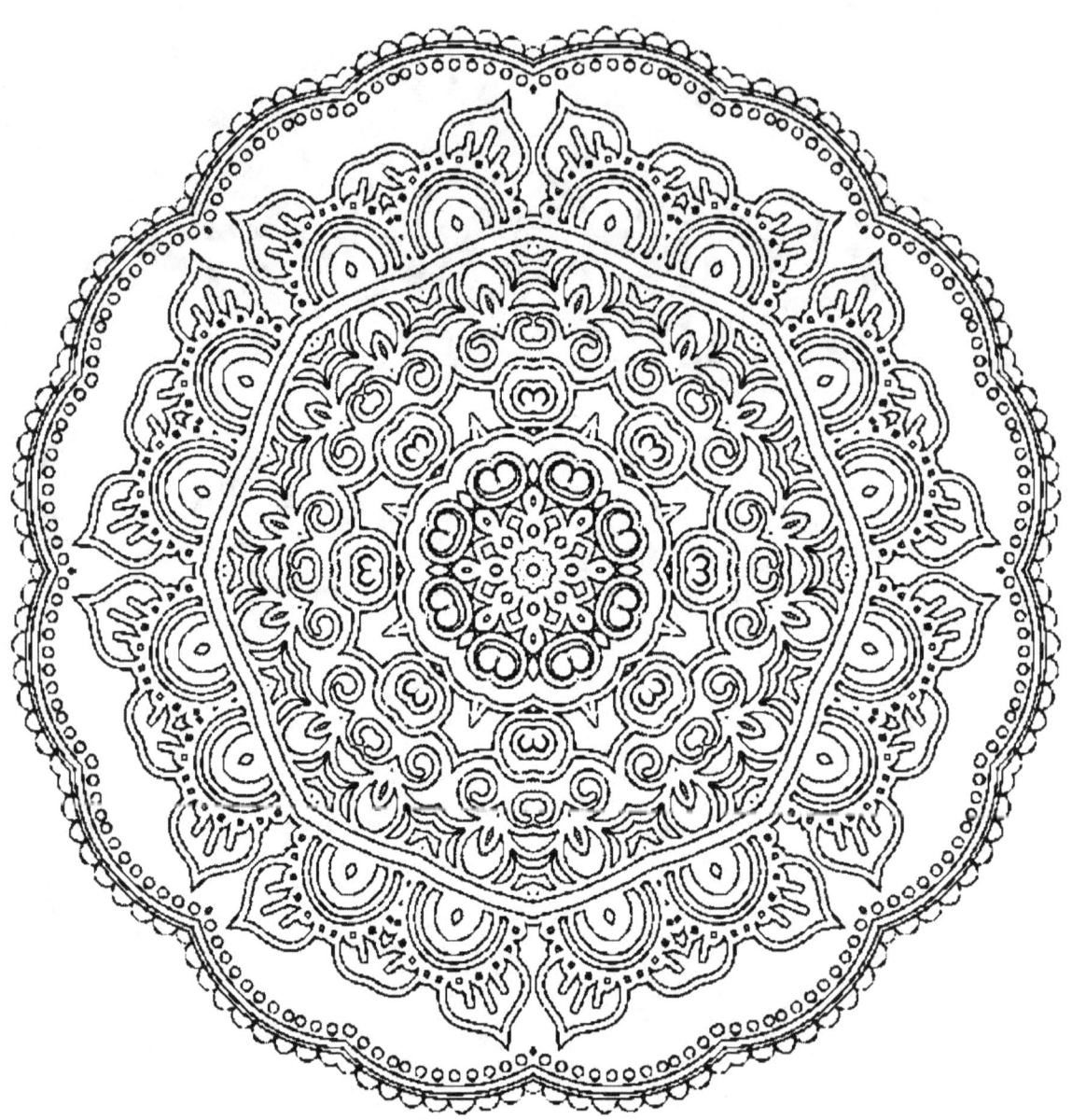

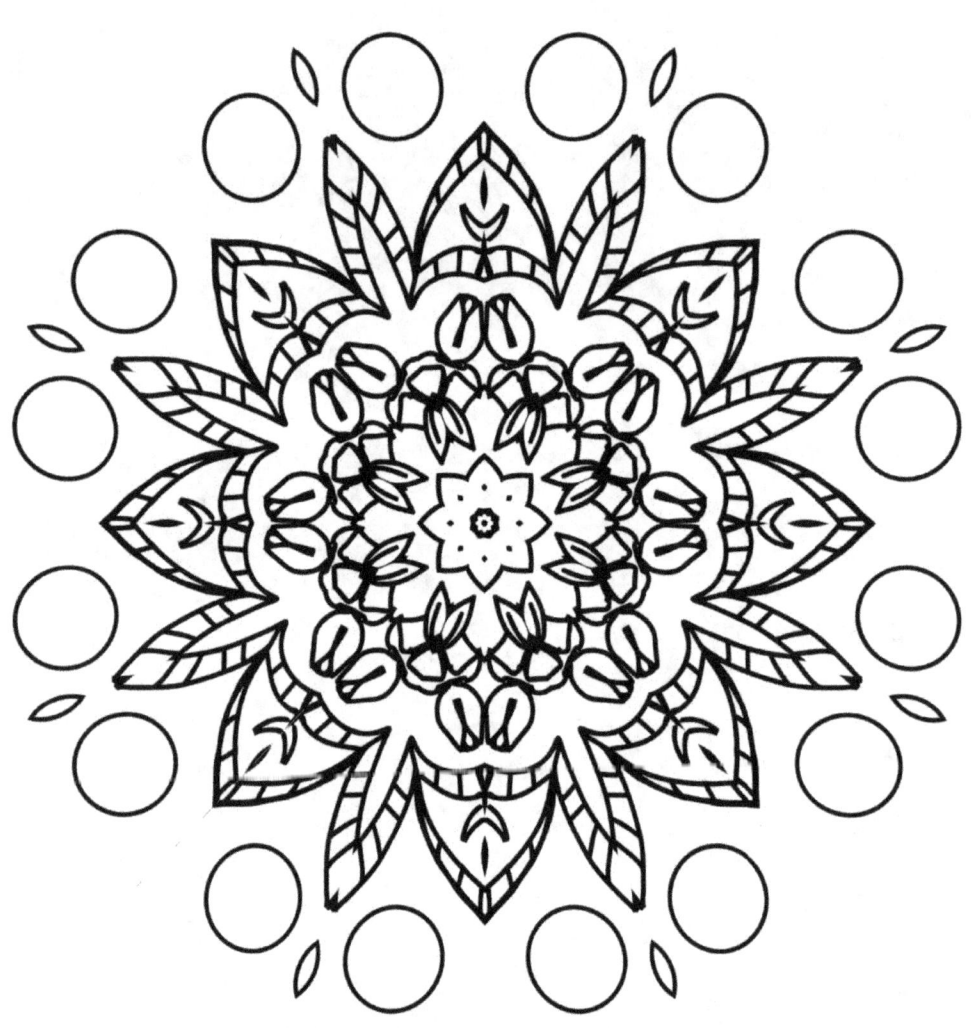

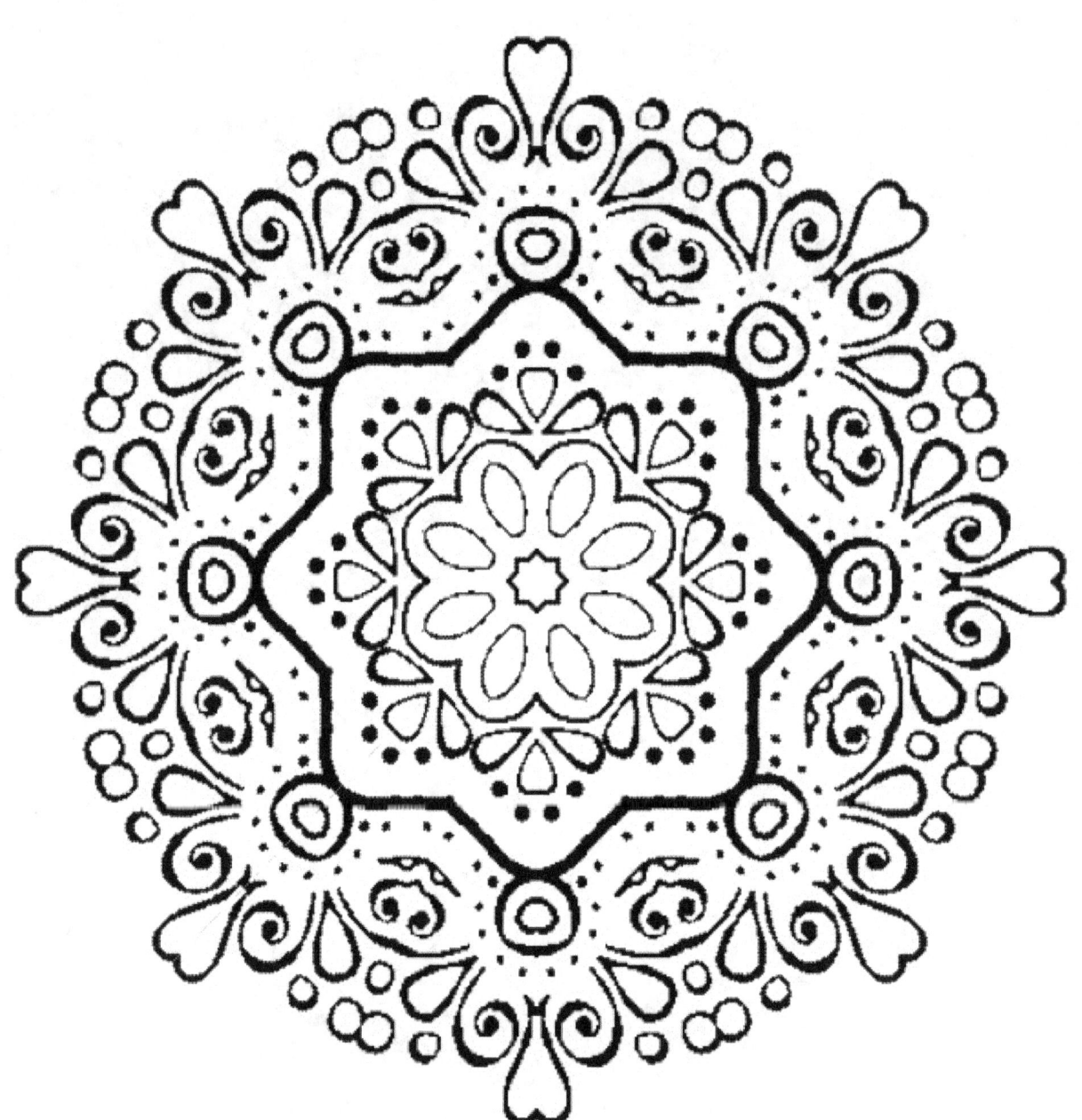

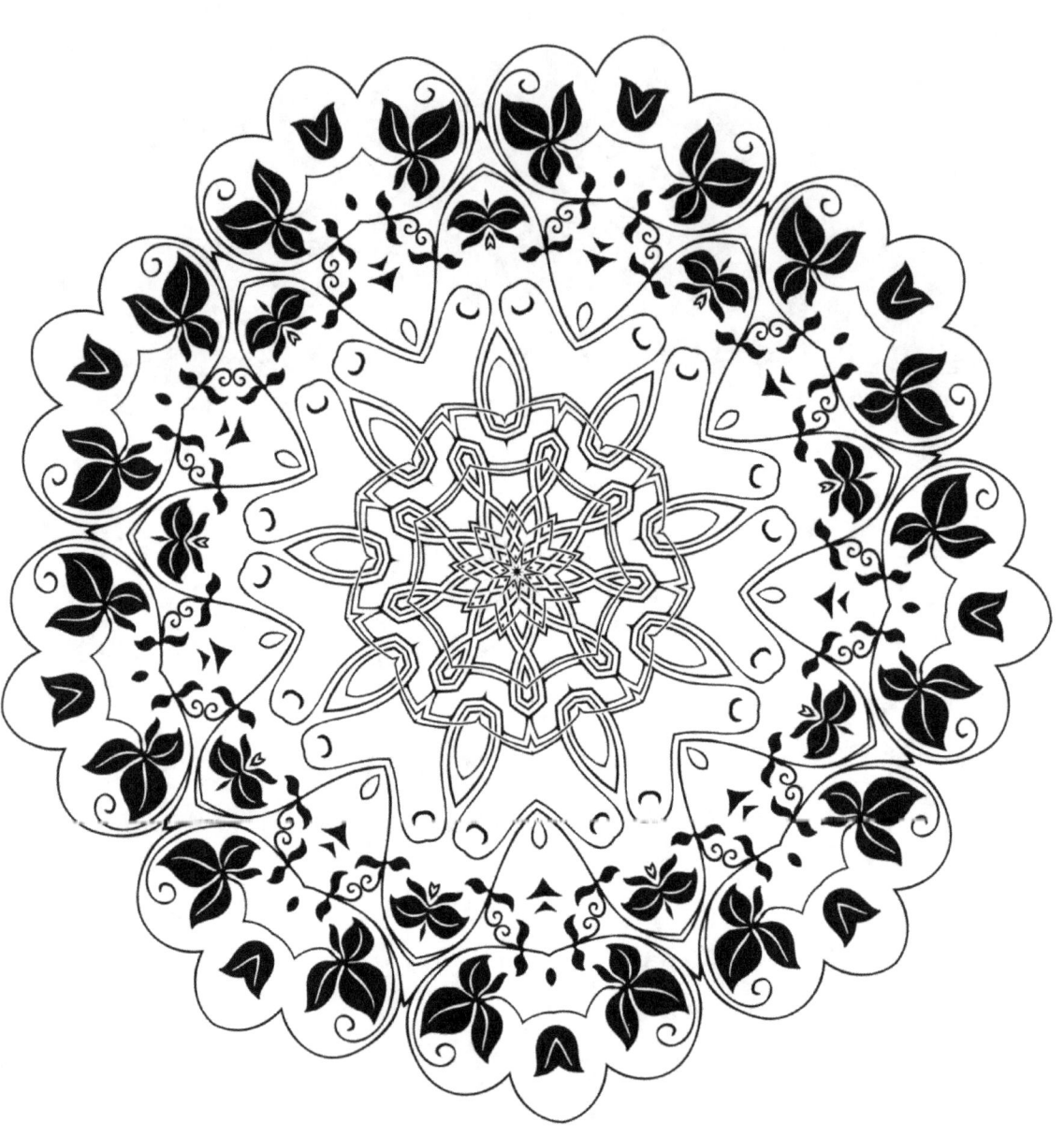

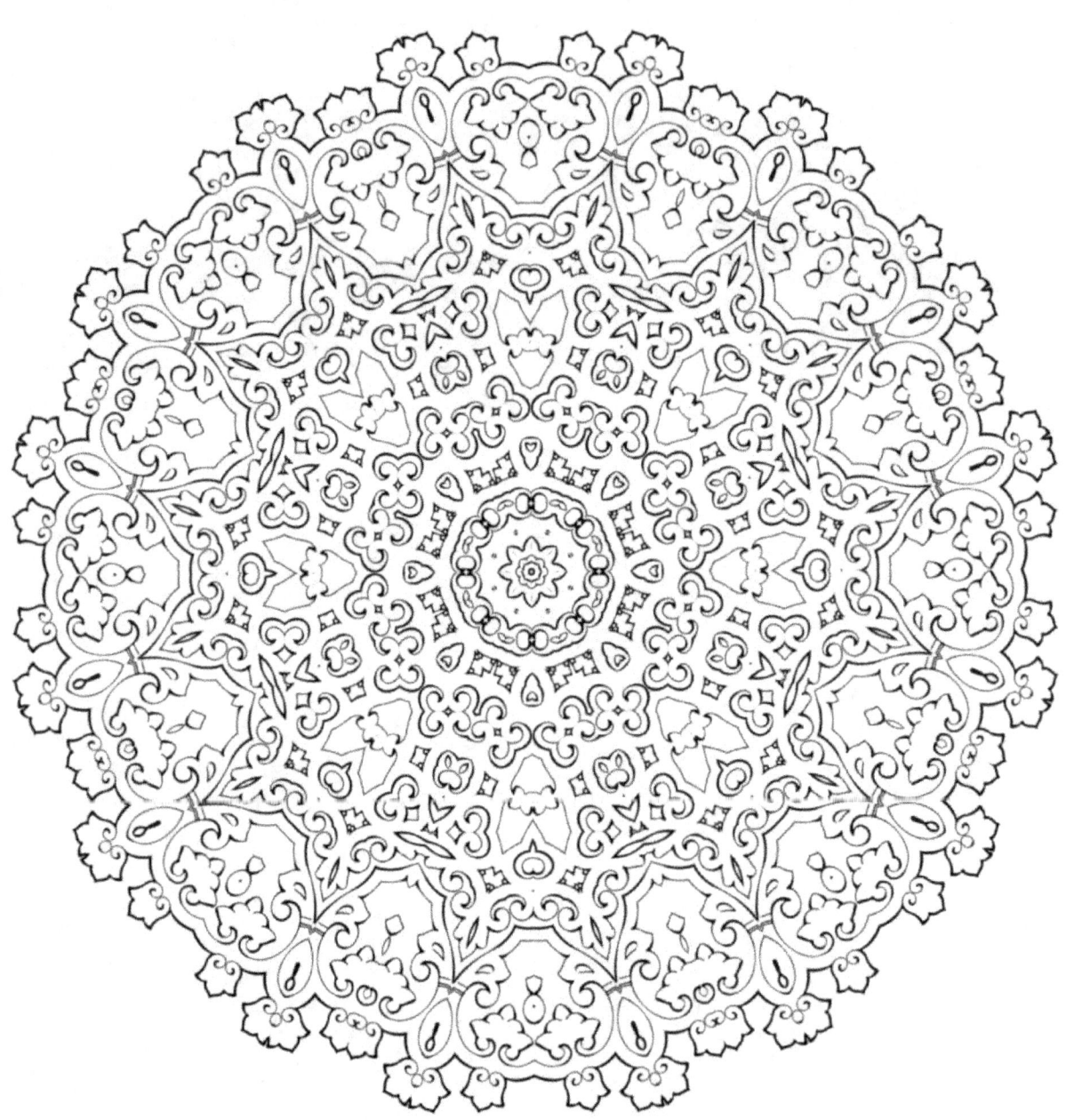

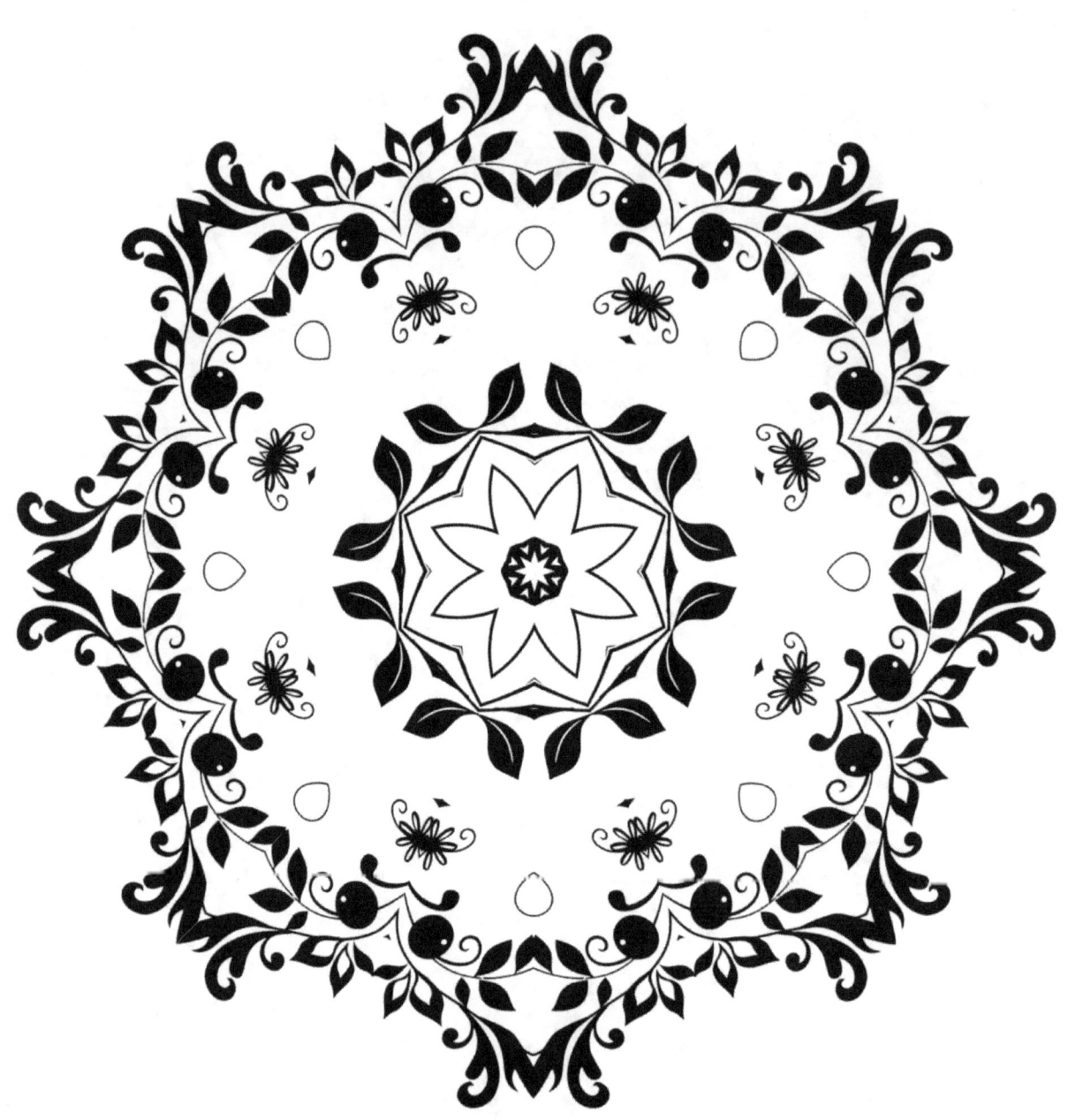

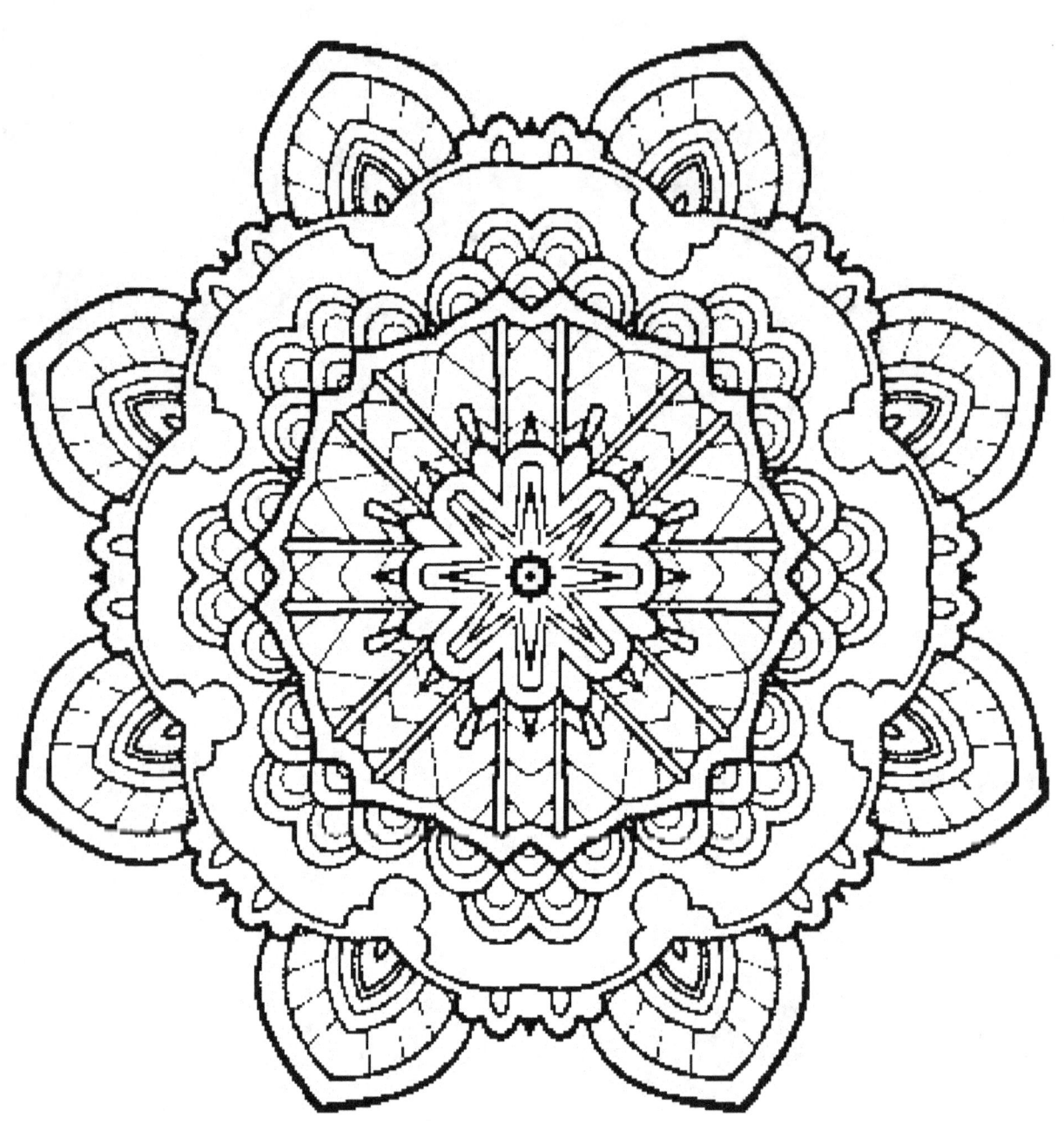

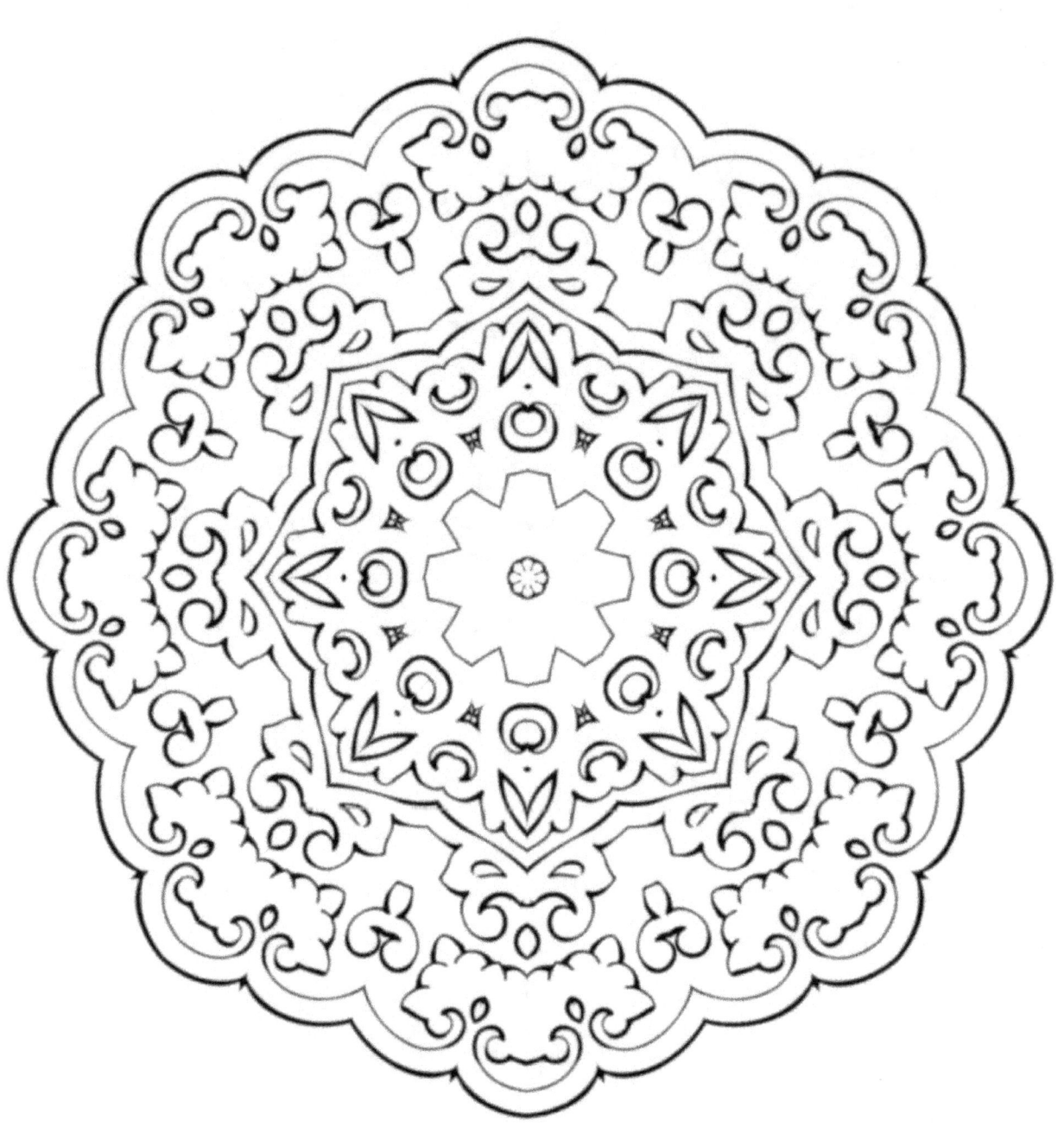

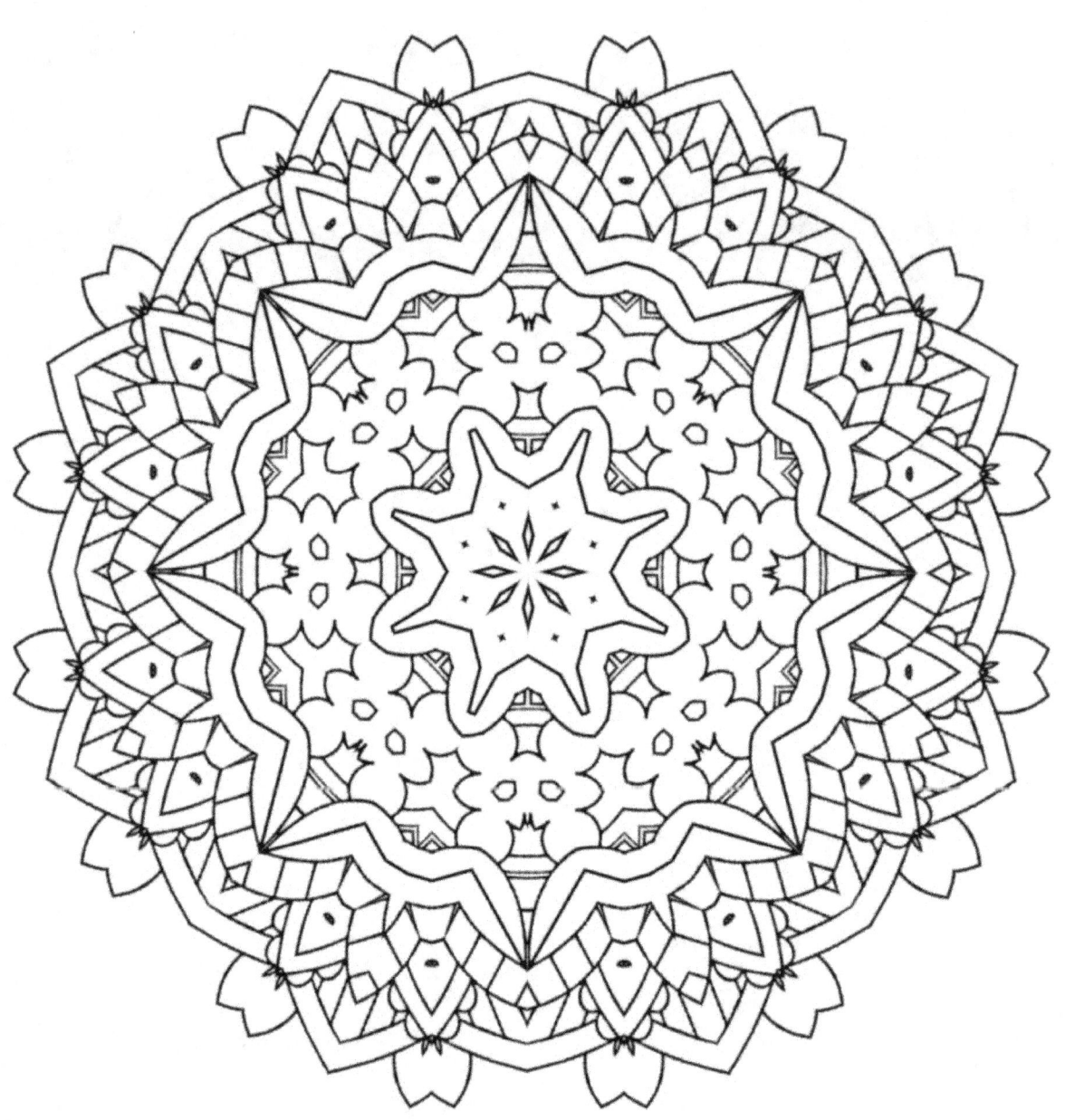

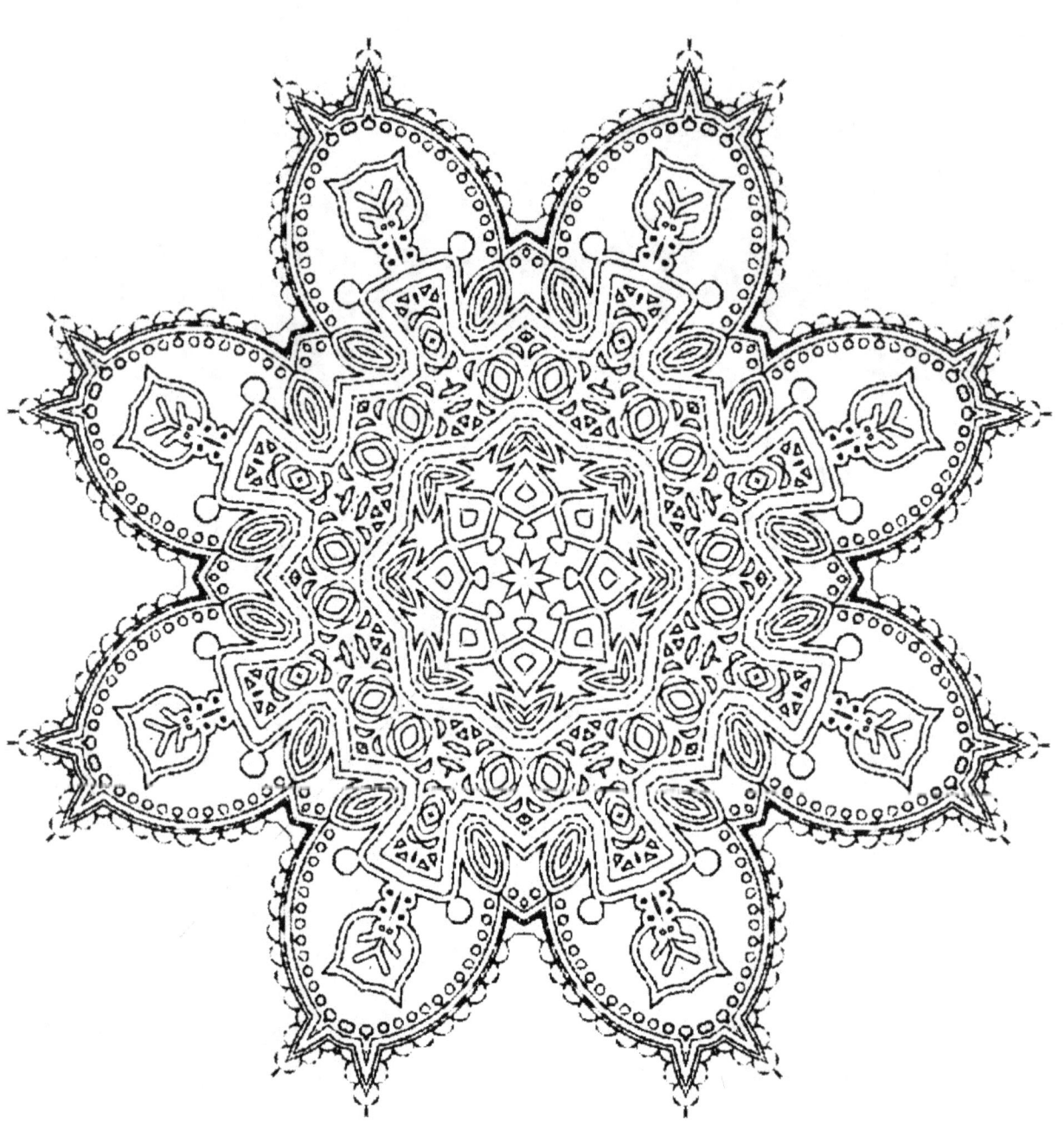

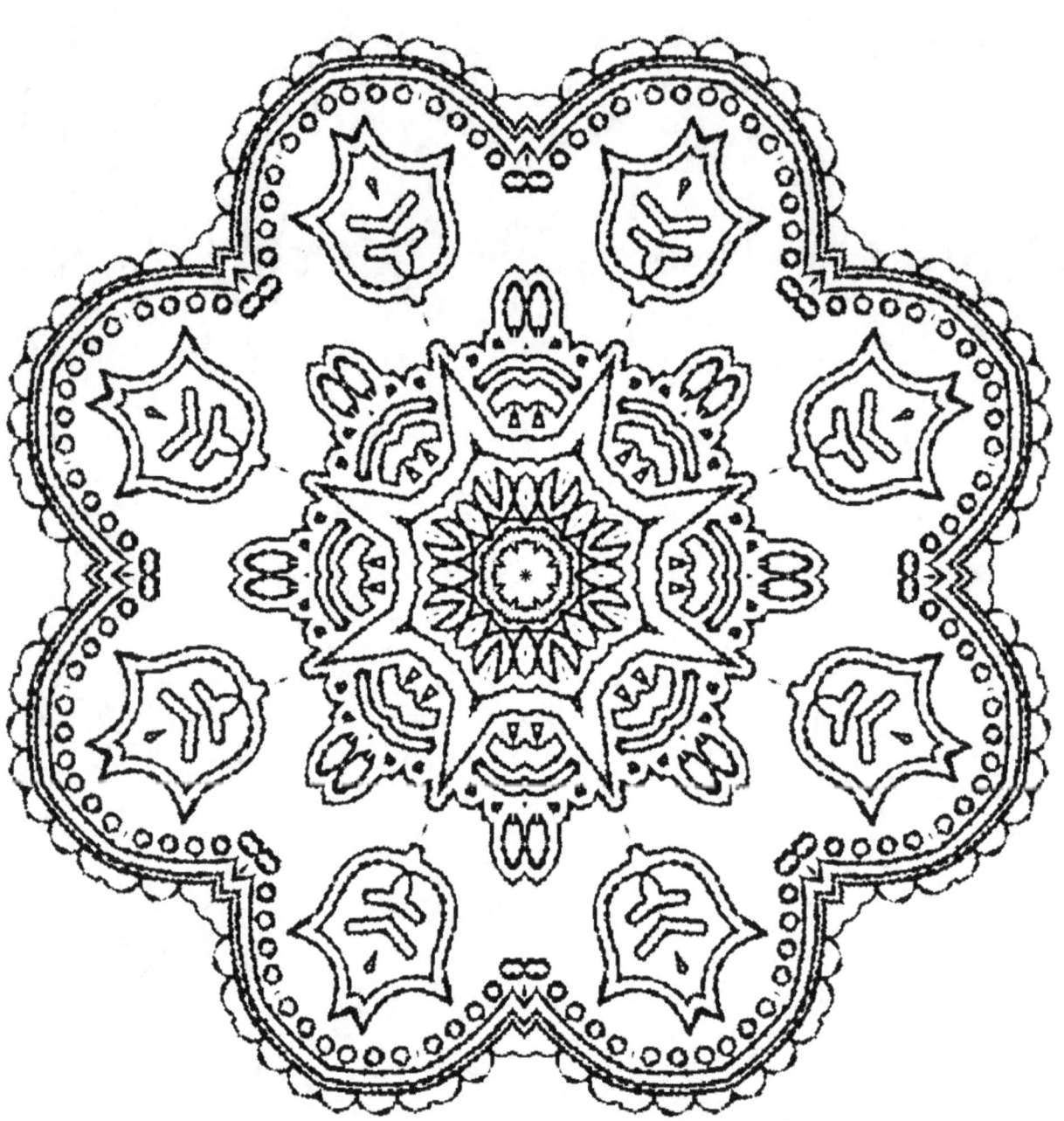

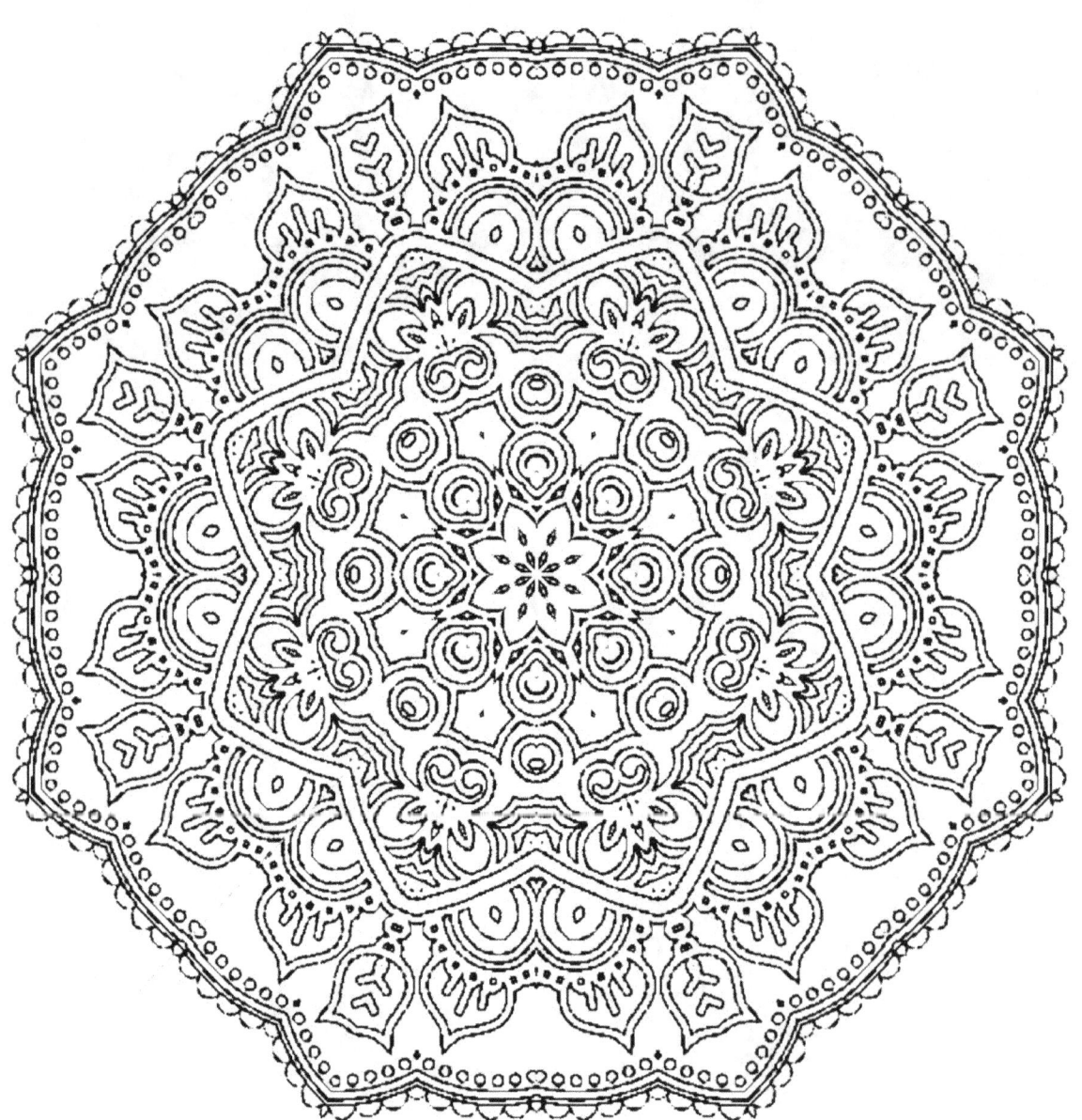

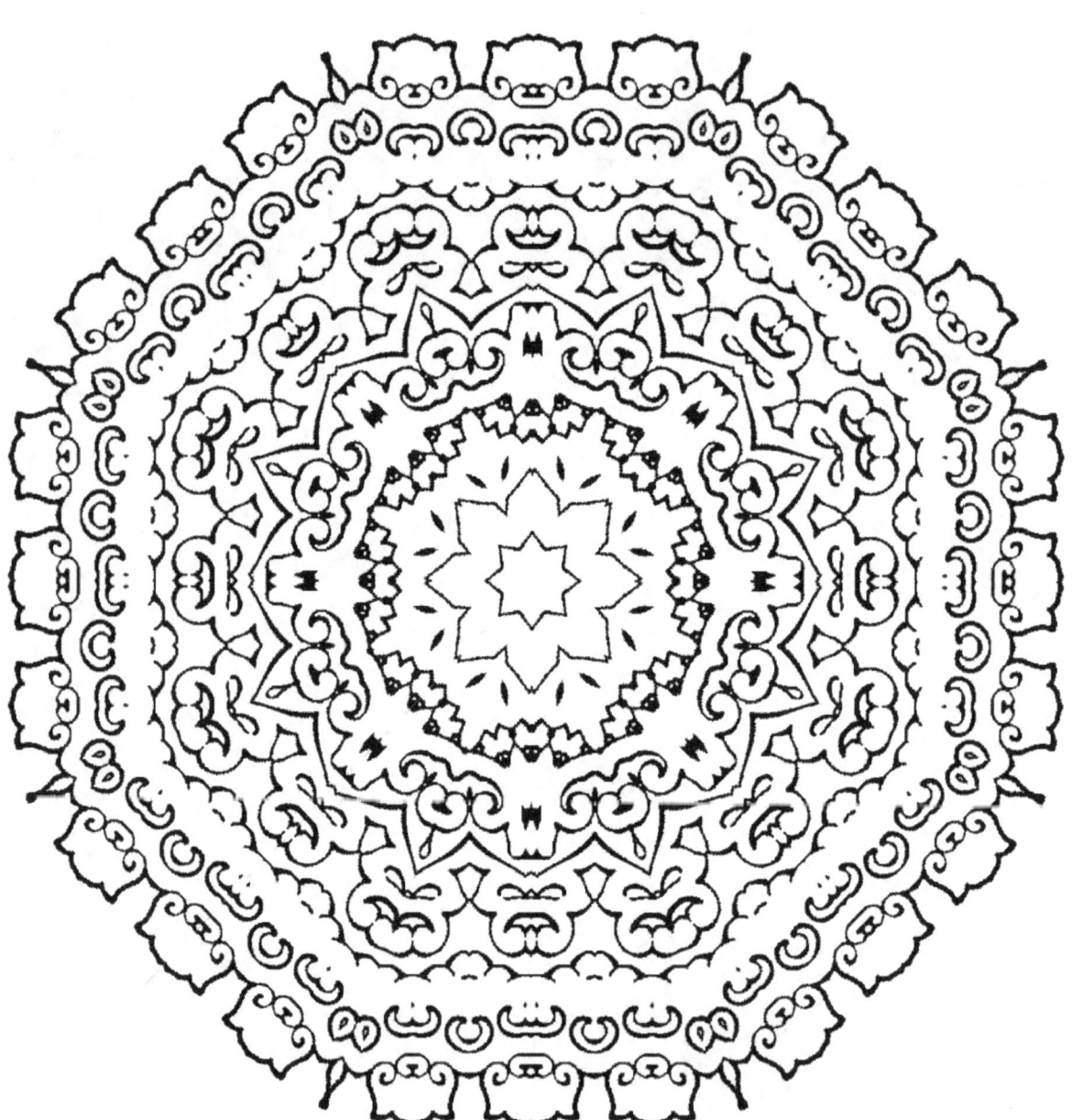

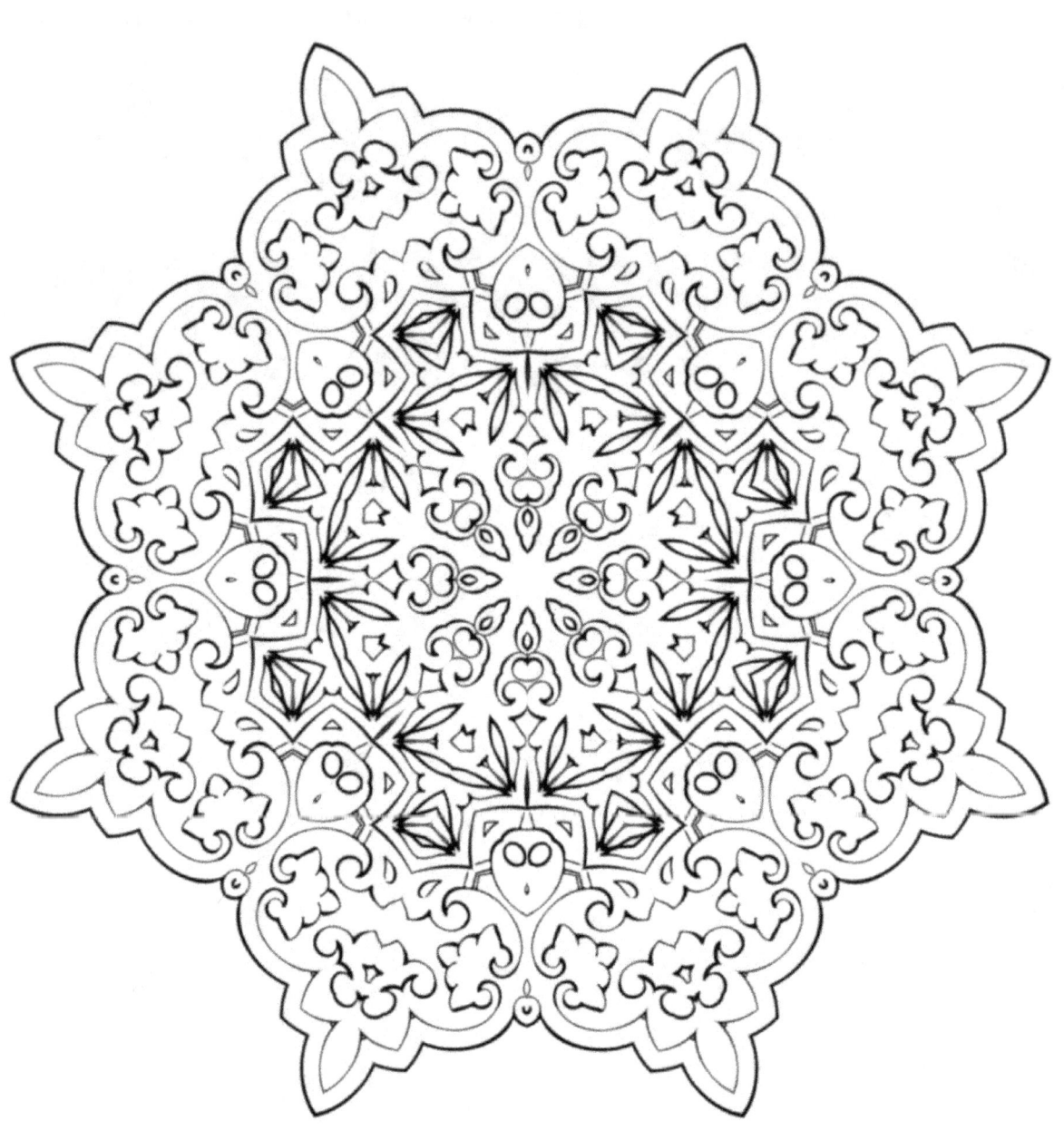

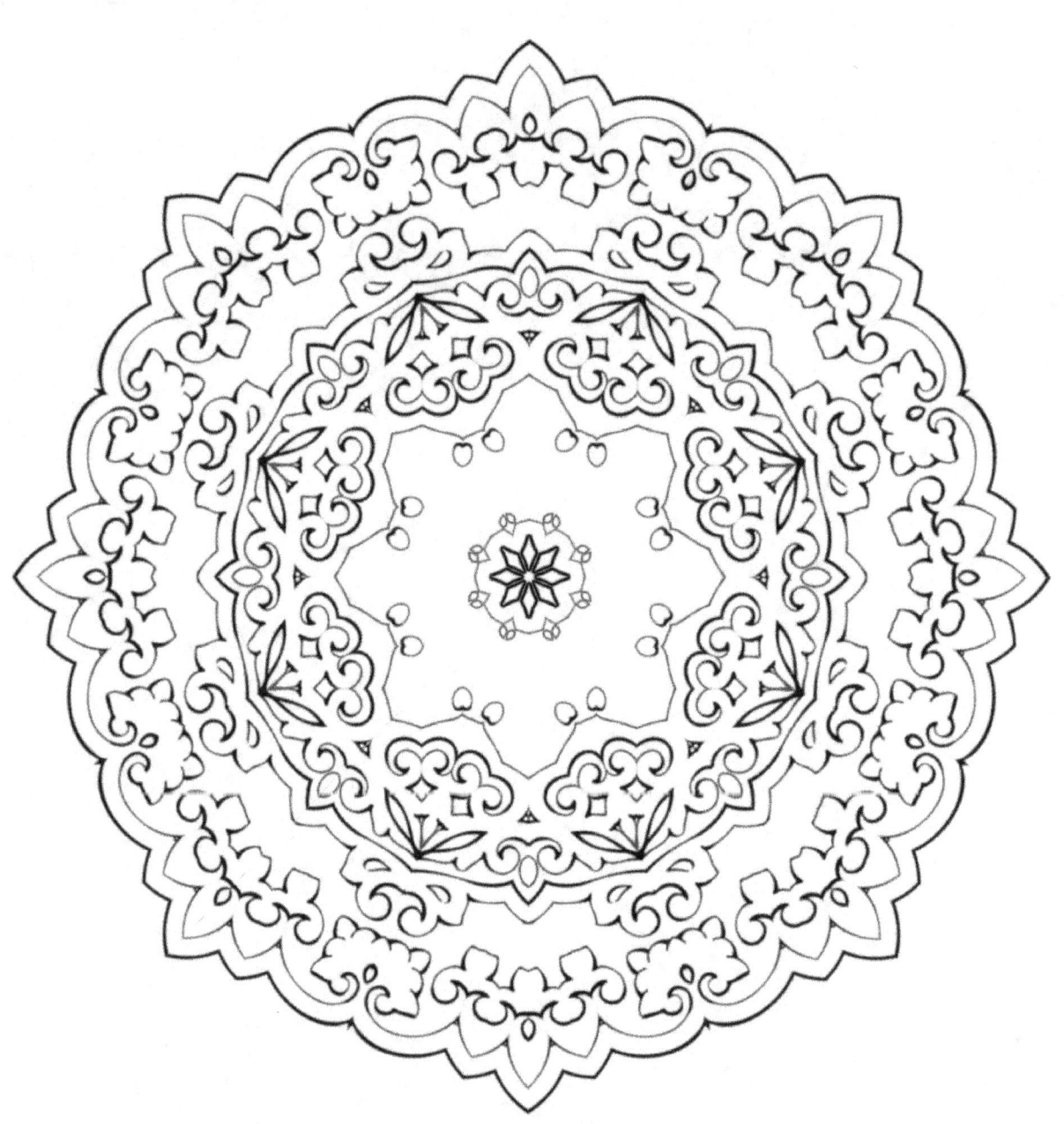

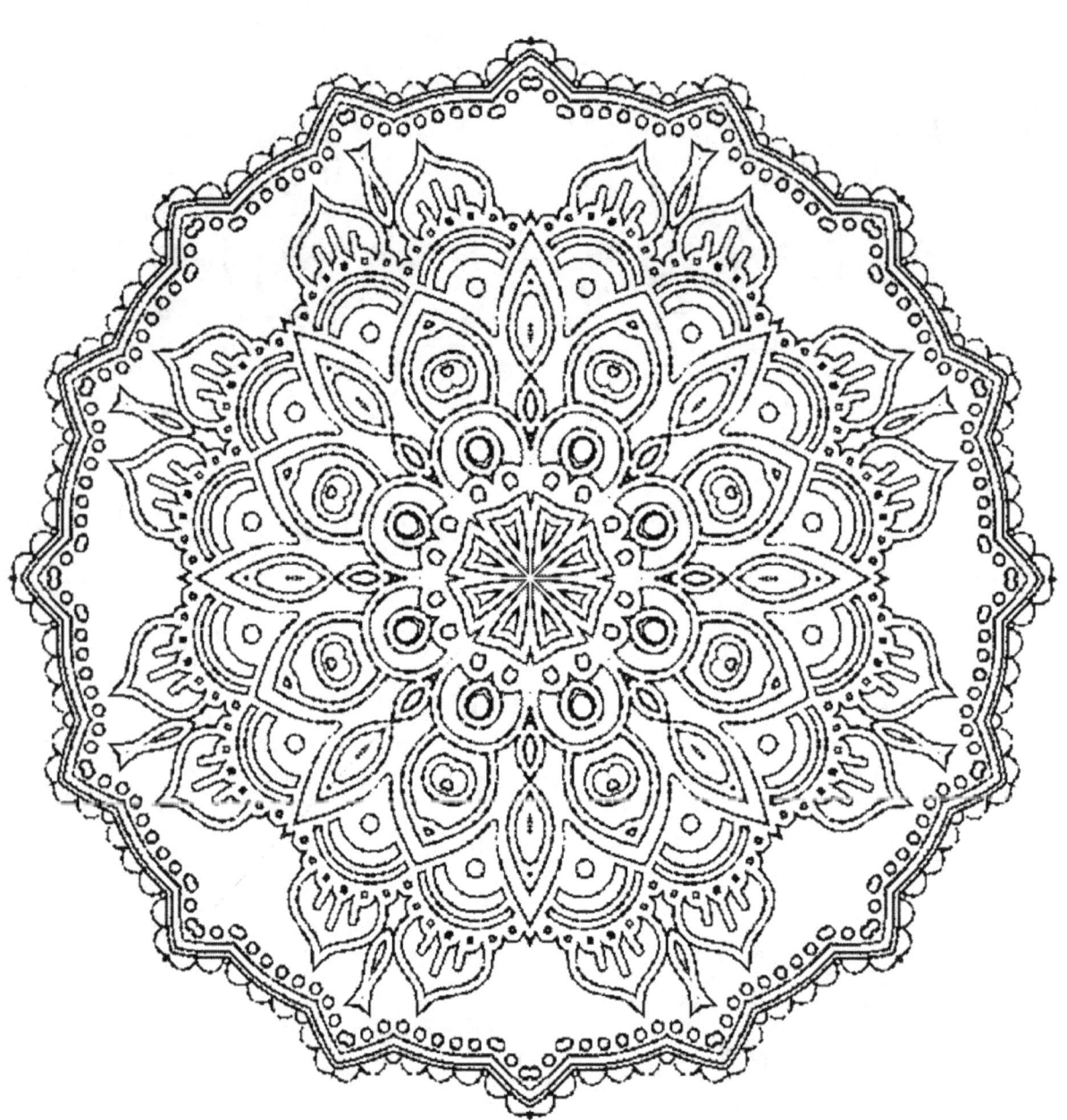

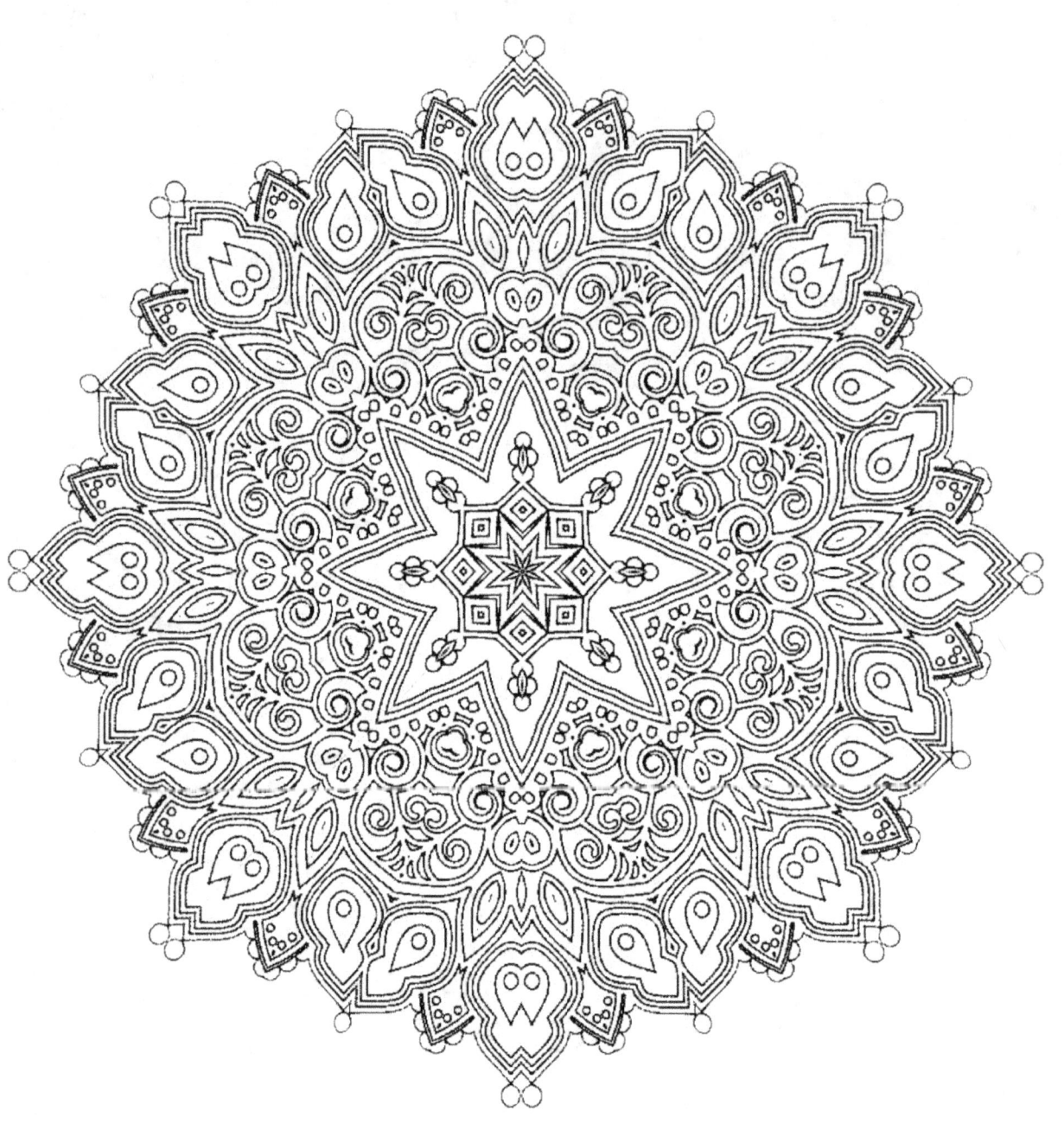

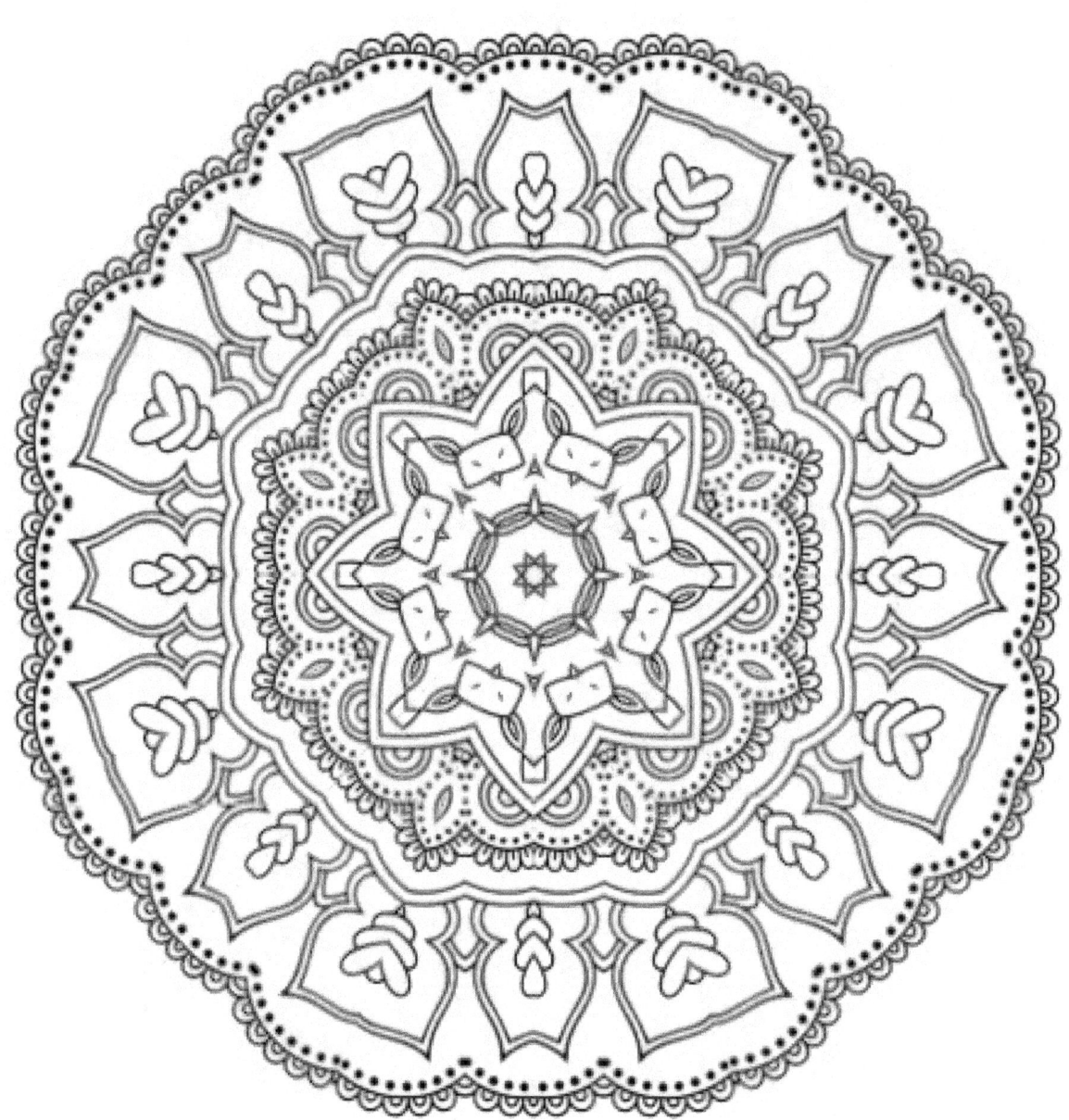

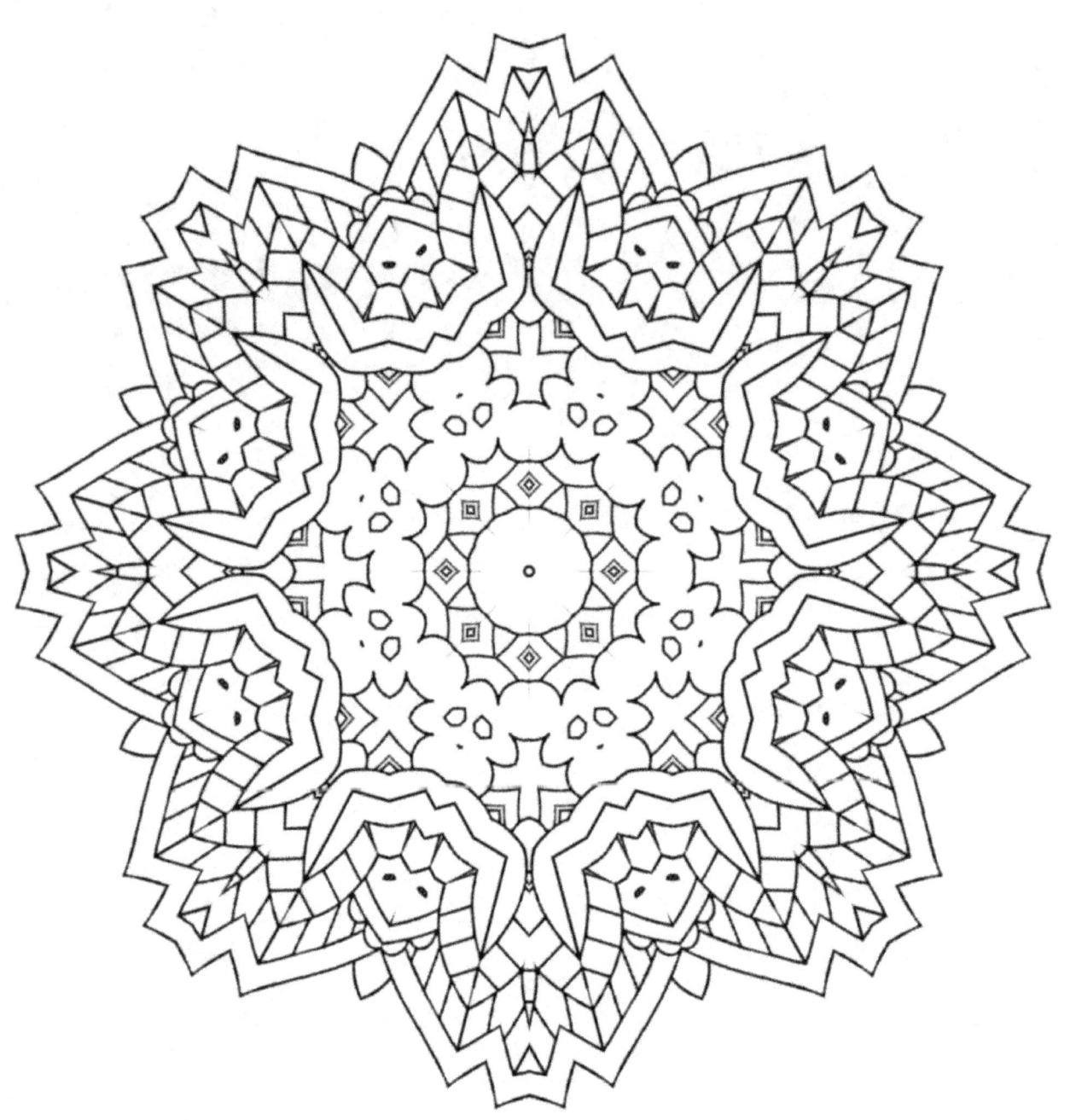

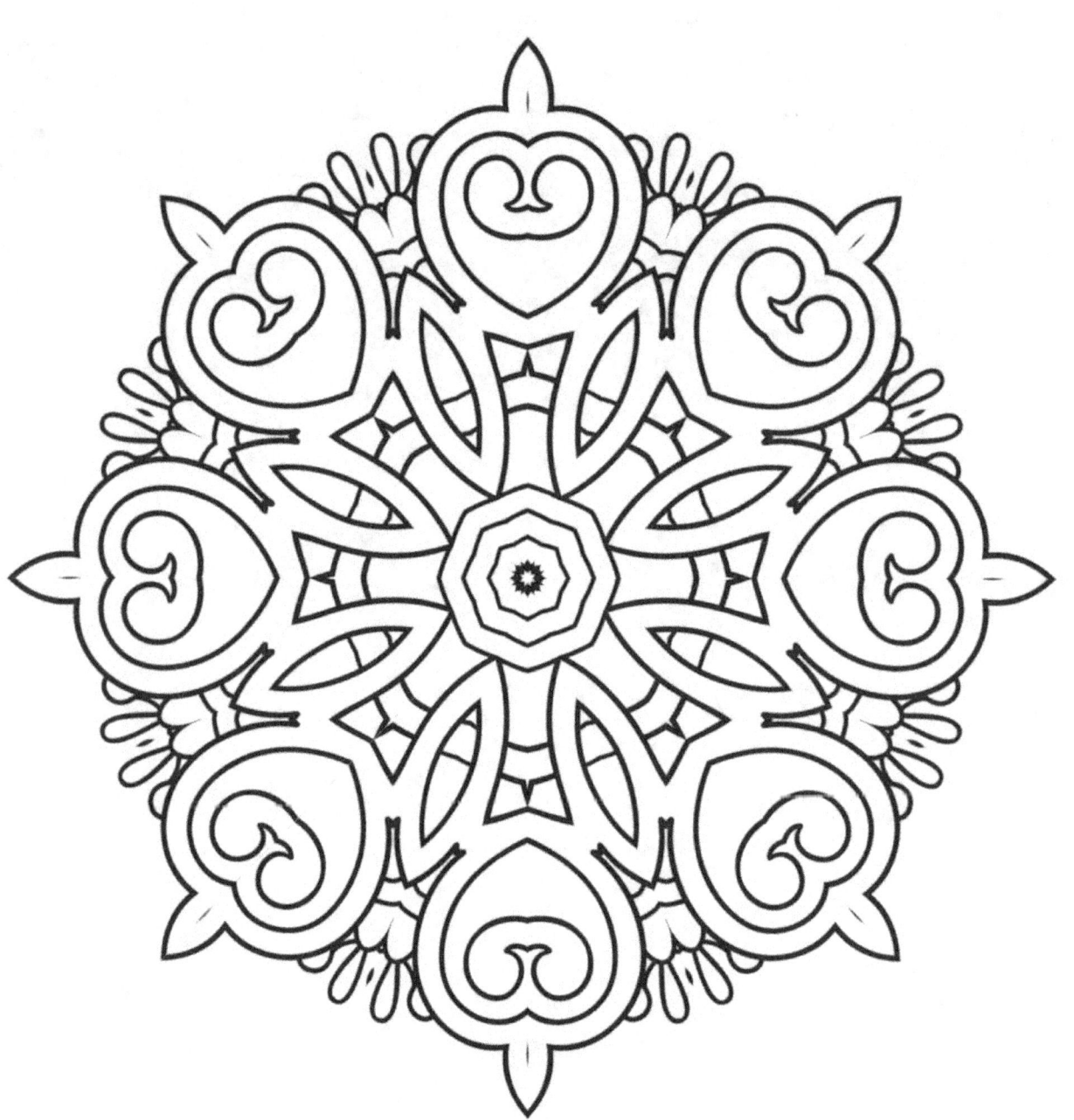

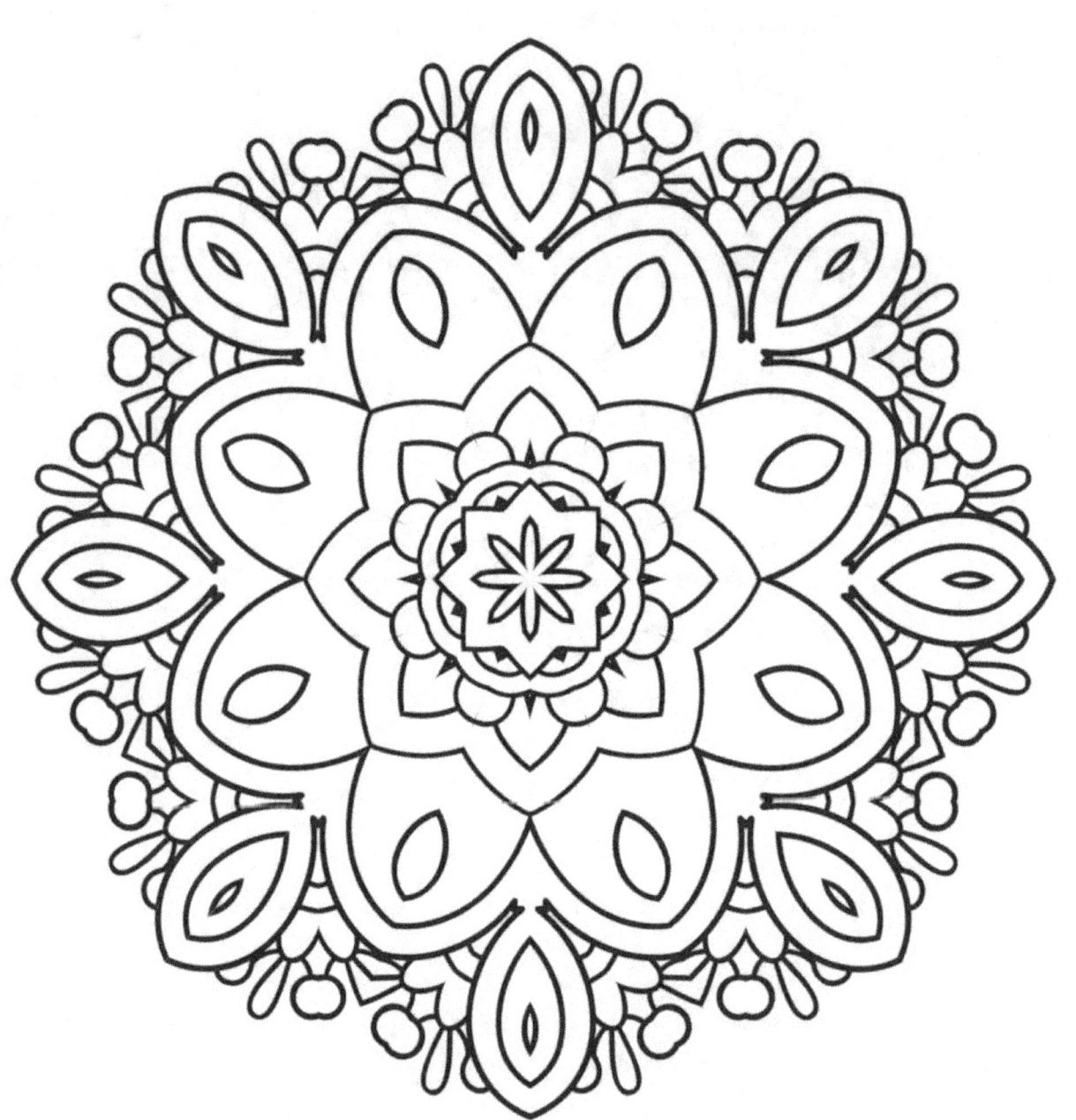

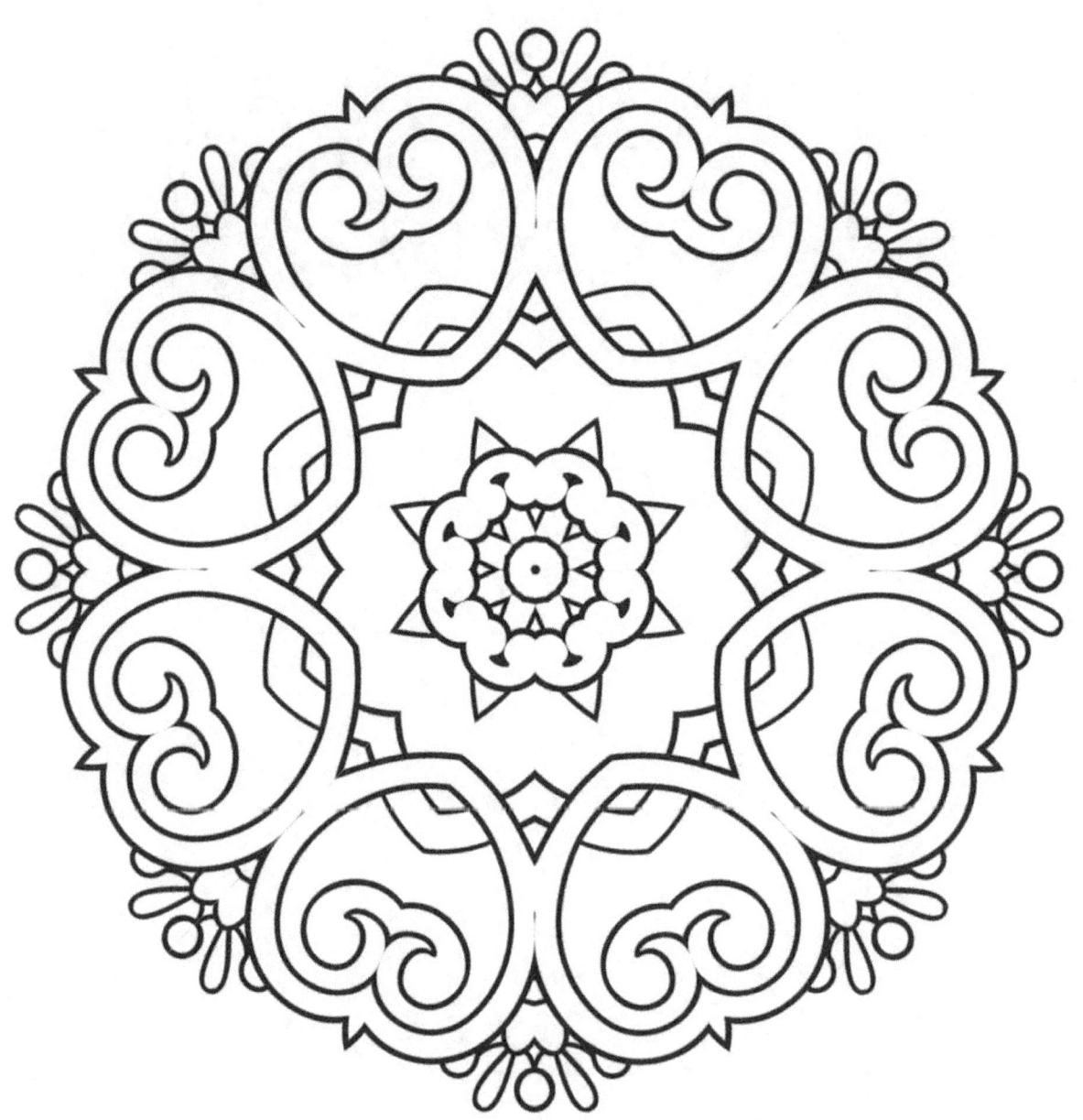

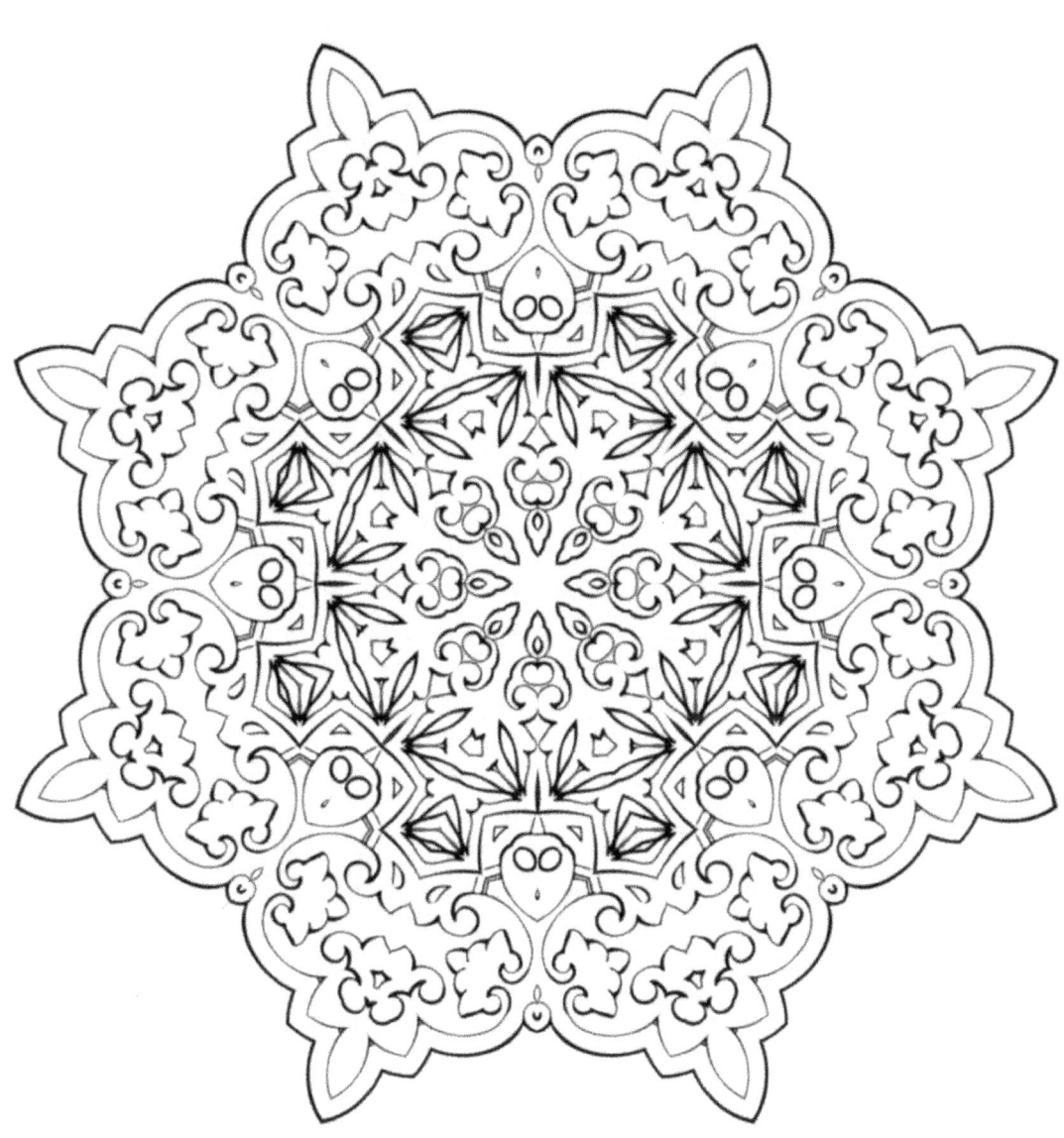

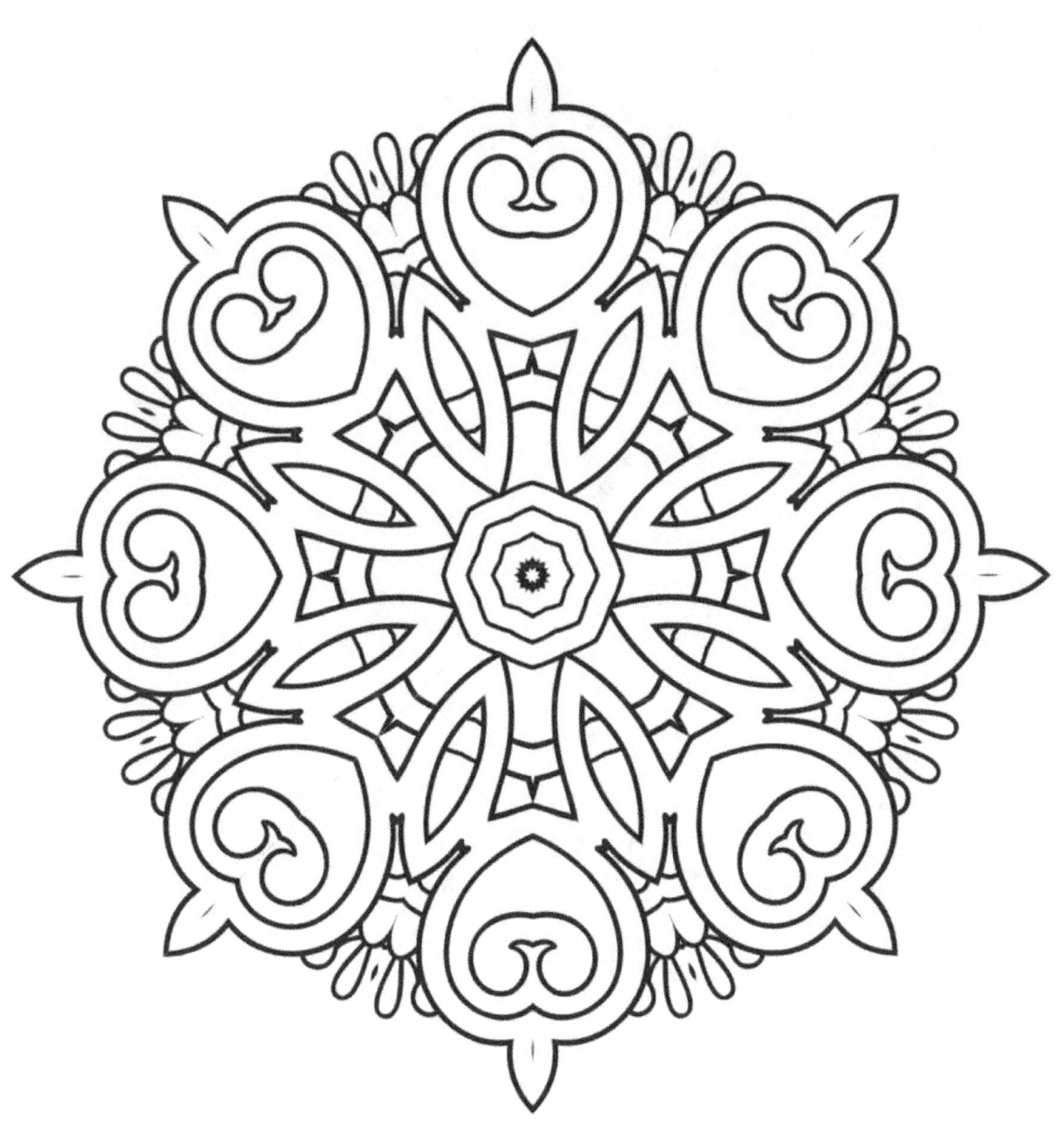

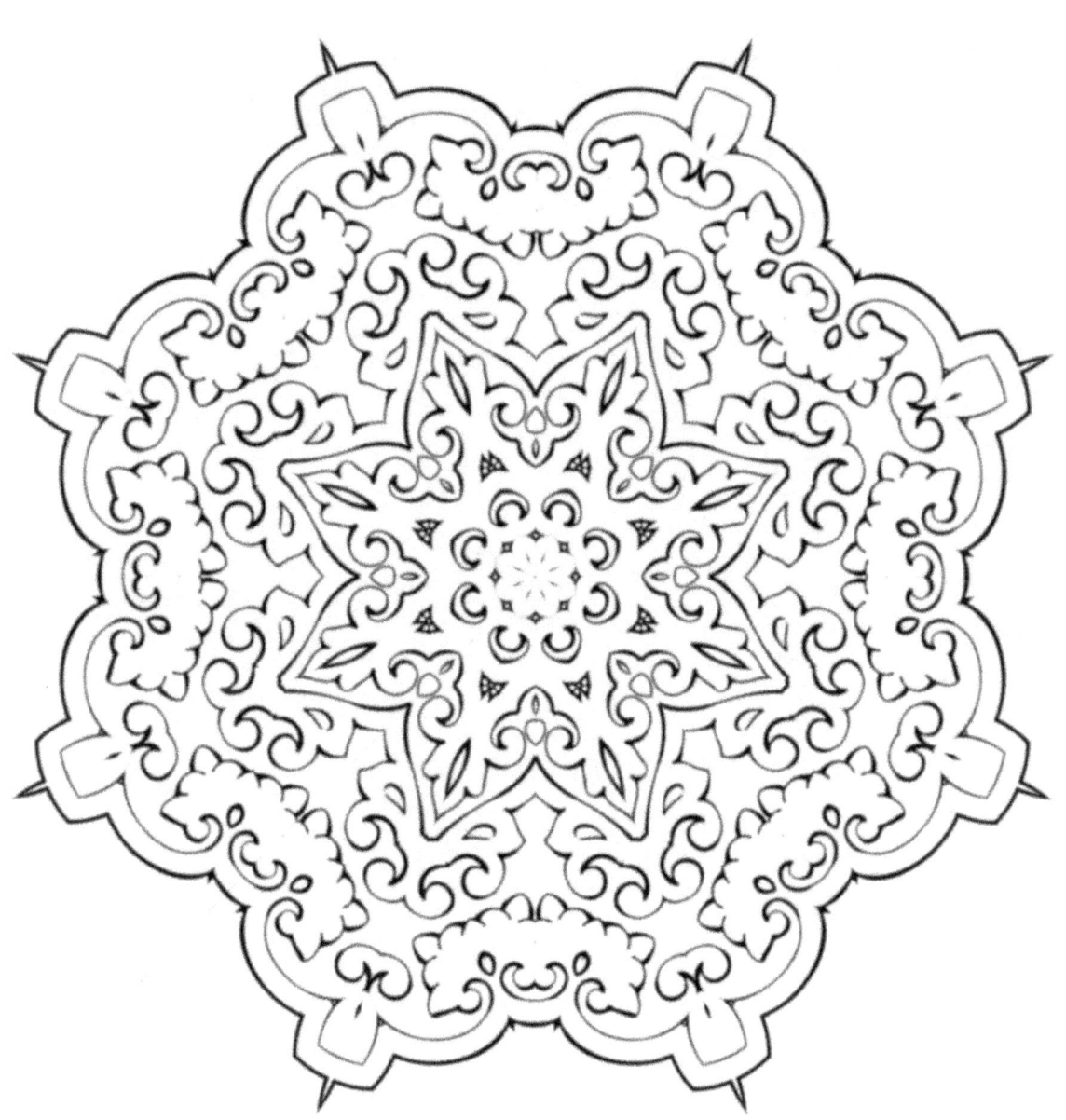

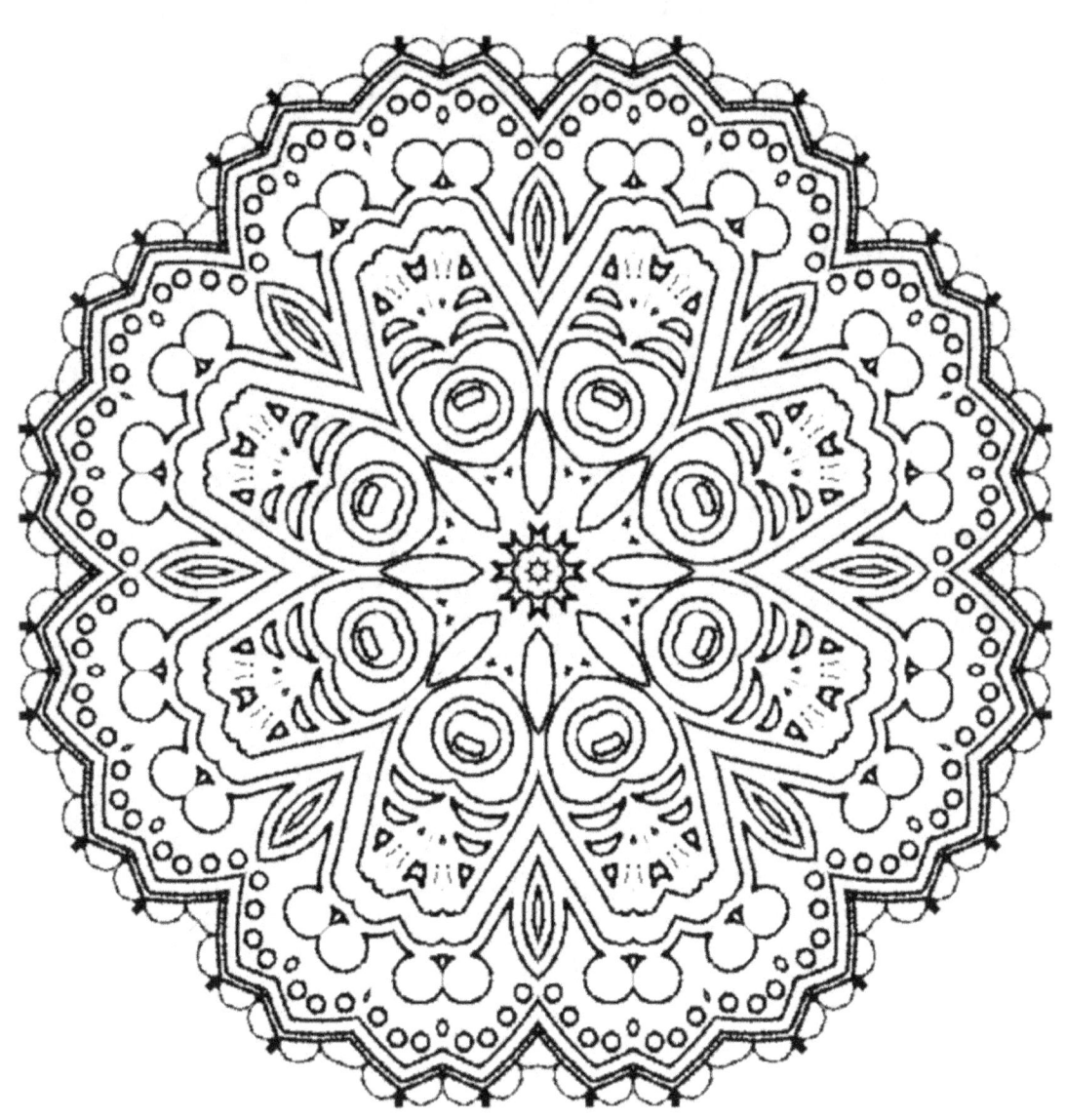

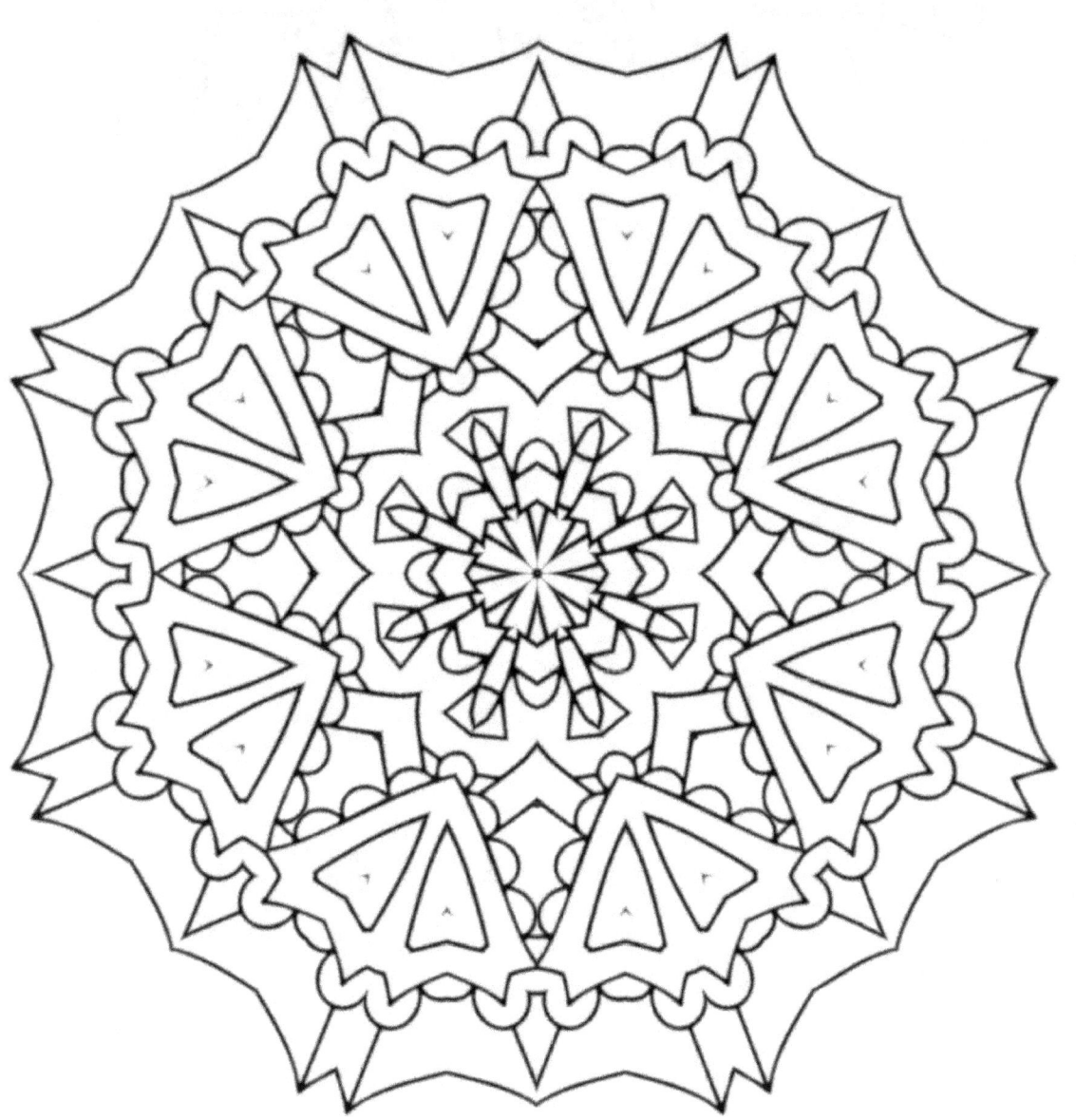

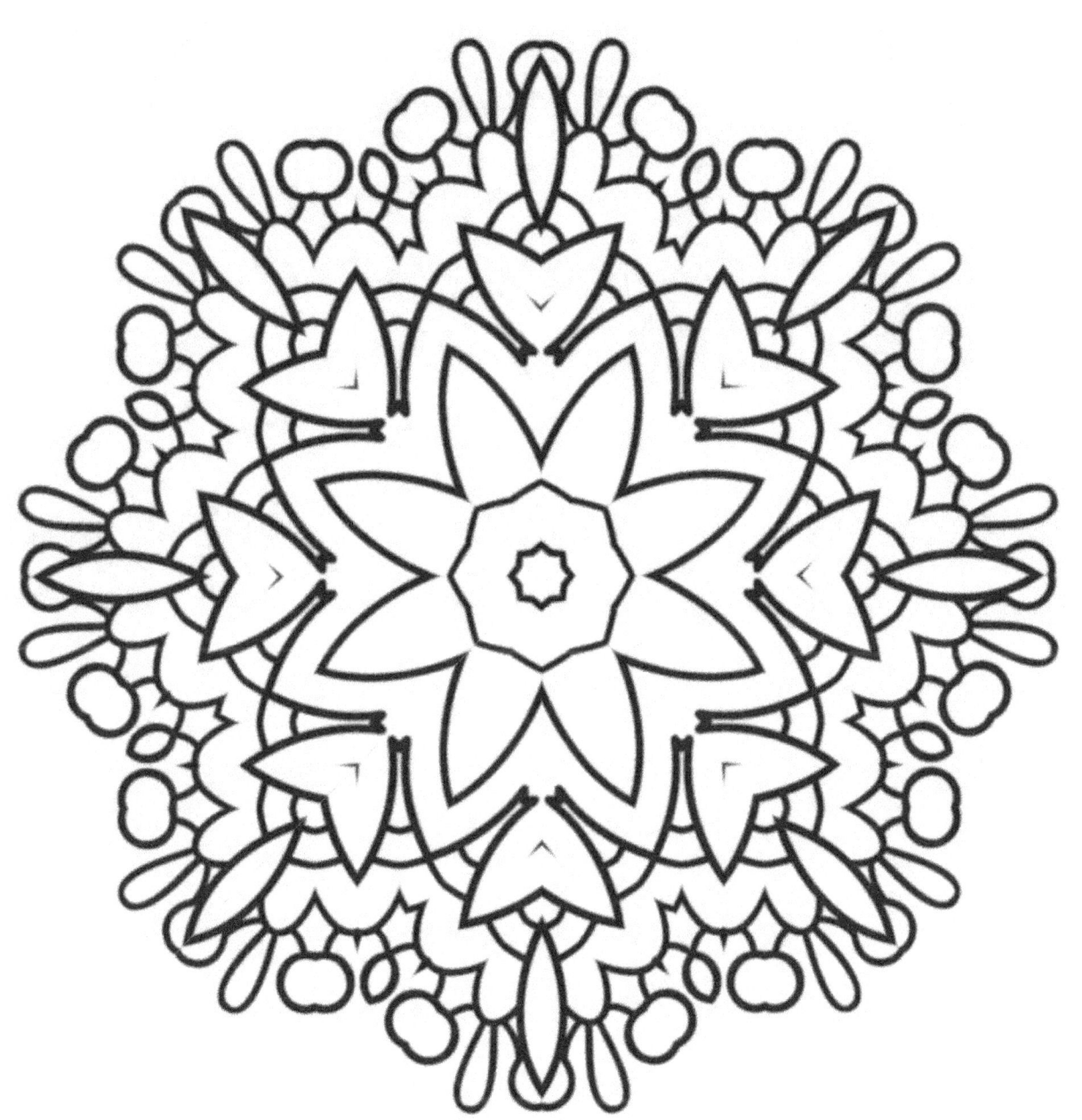

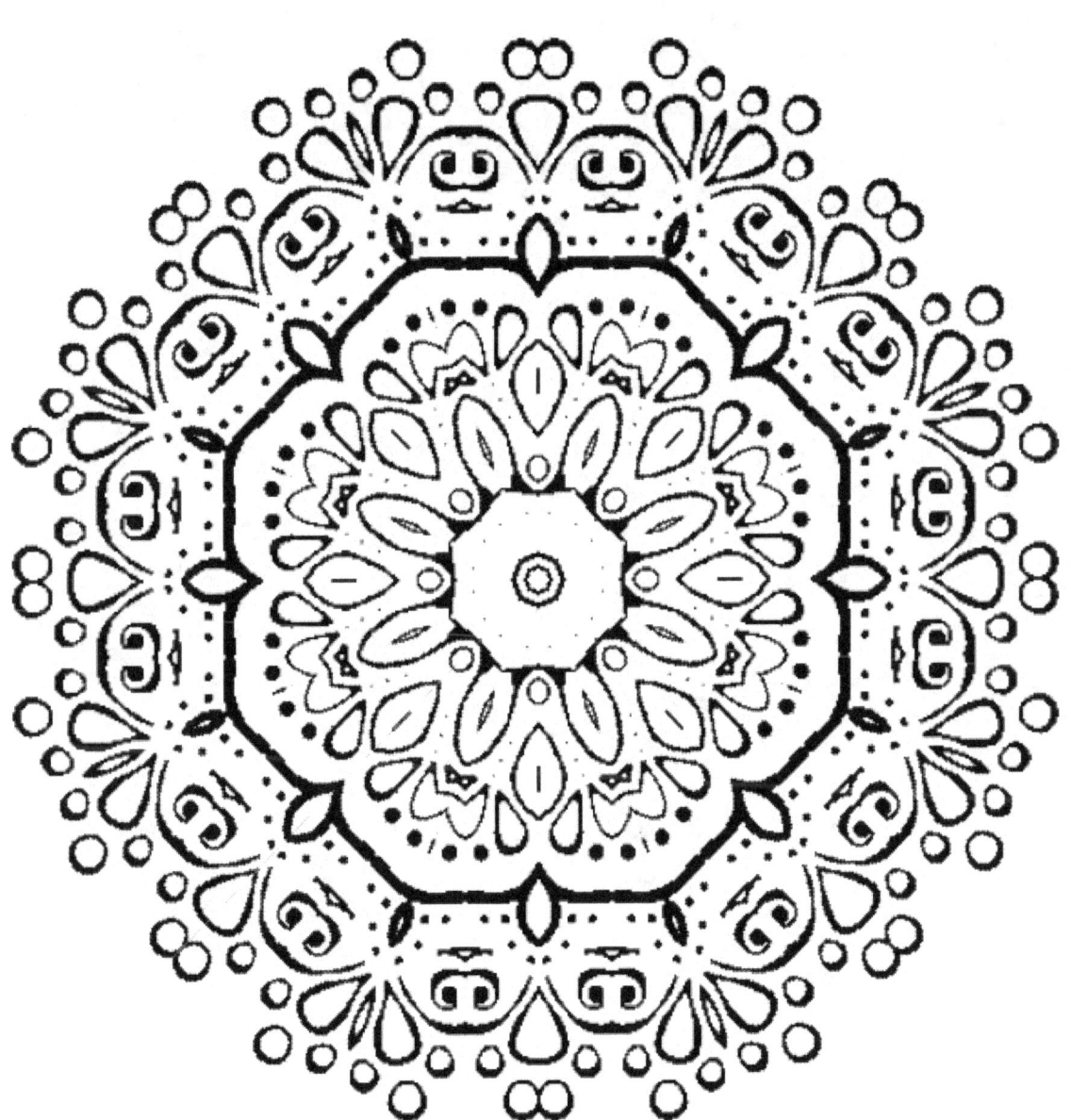

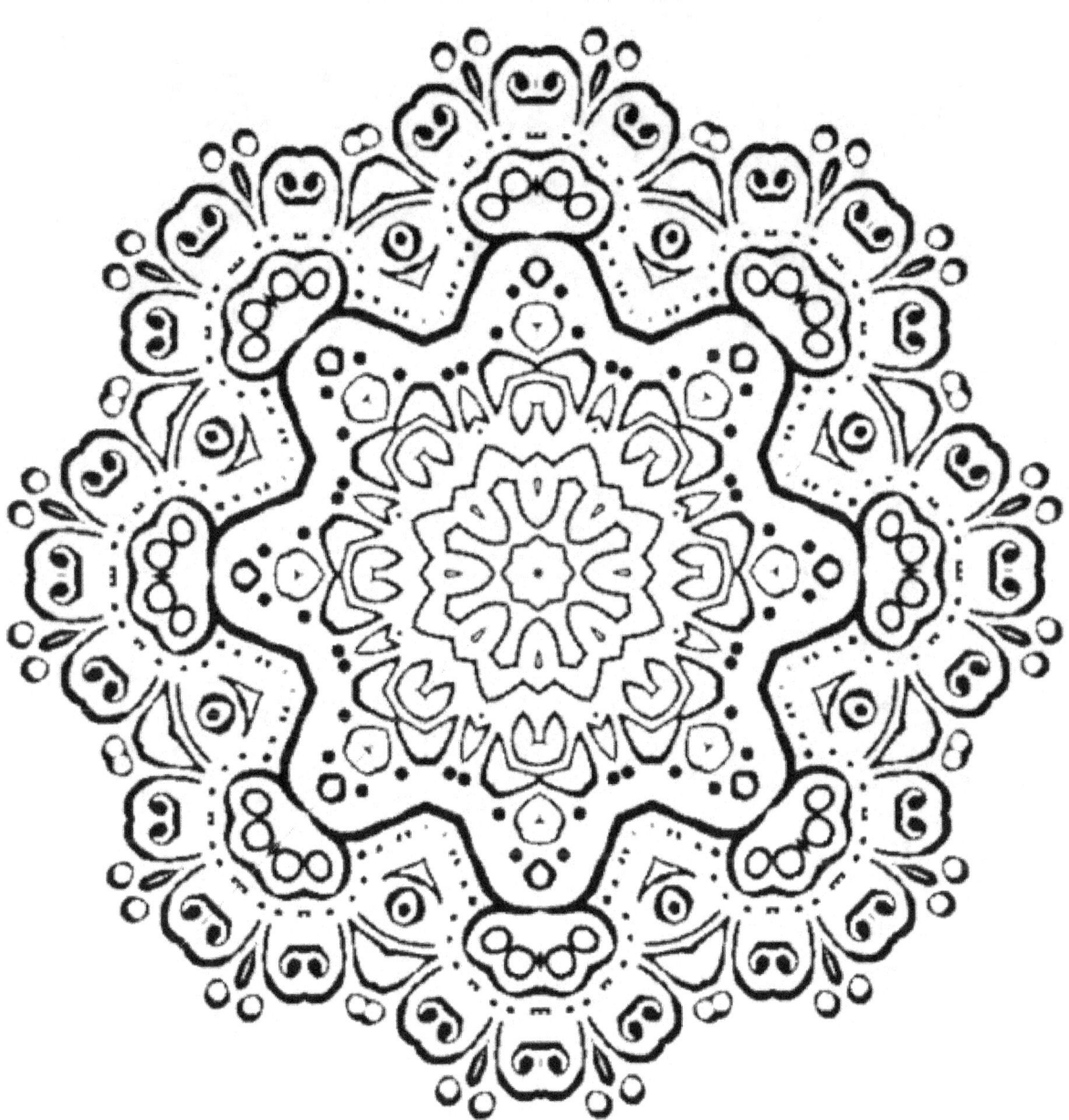

www.ingramcontent.com/pod-product-compliance
Lightning Source LLC
Chambersburg PA
CBHW080542220526
45466CB00010B/3000